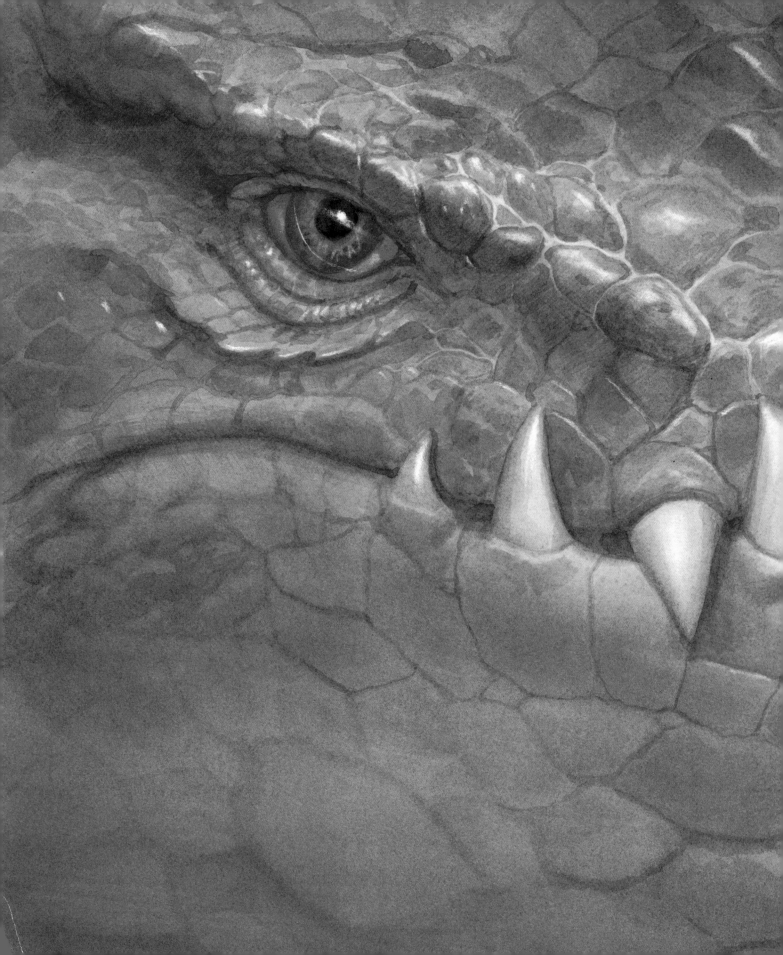

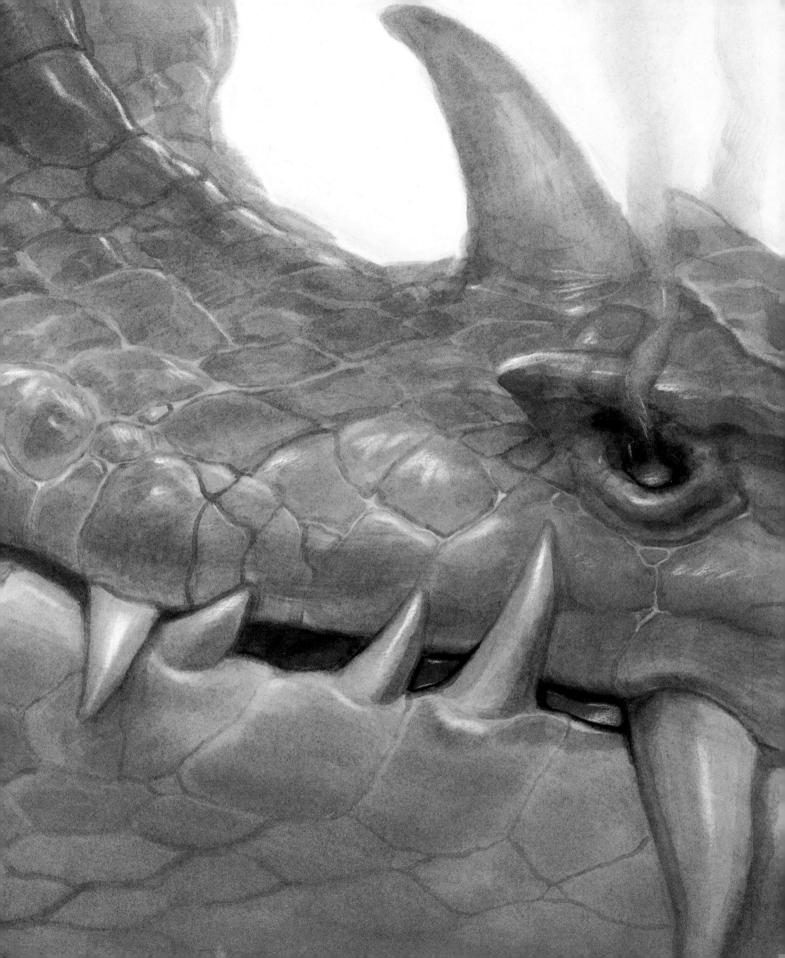

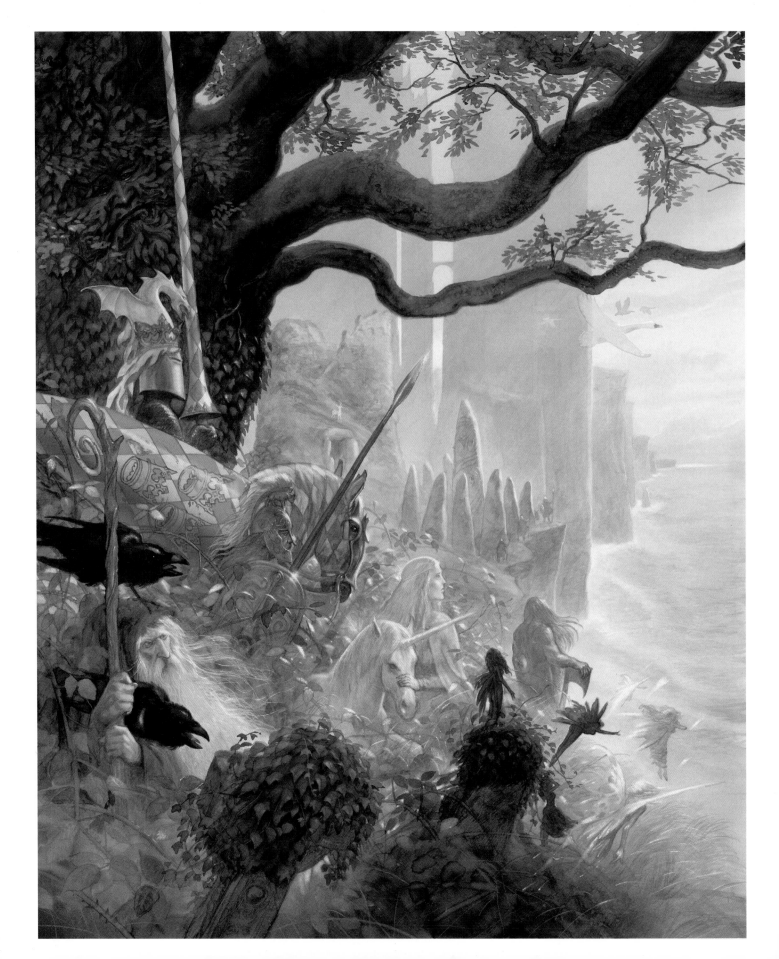

JOHN HOWE

fantasy art workshop

IMPACT

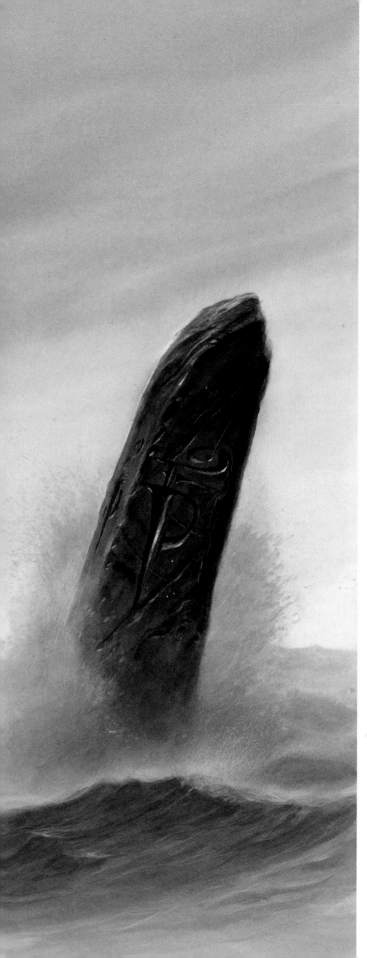

(PREVIOUS PAGE) CELTIC MYTH

 SKILL PILLARS ▶

A DAVID & CHARLES BOOK
Copyright © David & Charles Limited 2007

David & Charles is an F+W Publications Inc. company
4700 East Galbraith Road
Cincinnati, OH 45236

First published in the UK in 2007

Text and illustrations copyright © John Howe 2007

John Howe has asserted his right to be identified as author of this work in
accordance with the Copyright, Designs and Patents Act, 1988.

A catalogue record for this book is available from the British Library.

ISBN-13: 978-0-7153-1009-7 hardback
ISBN-10: 0-7153-1009-9 hardback
ISBN-13: 978-0-7153-1010-3 paperback
ISBN-10: 0-7153-1010-2 paperback

Printed in U.S.A. by CJK
for David & Charles
Brunel House Newton Abbot Devon

Commissioning Editor Freya Dangerfield
Senior Editor Jennifer Fox-Proverbs
Art Editor Sarah Underhill
Production Controller Beverley Richardson
Photographer Kim Sayers
Project Editor Beverley Jollands

Visit our website at www.davidandcharles.co.uk

David & Charles books are available from all good bookshops; alternatively you
can contact our Orderline on 0870 9908222 or write to us at FREEPOST
EX2 110, D&C Direct, Newton Abbot, TQ12 4ZZ (no stamp required UK only);
US customers call 800-289-0963 and Canadian customers call 800-840-5220.

CONTENTS

FOREWORD BY TERRY GILLIAM

OK … let's be totally honest.
This book has depressed me … really depressed me.
Let me explain.

I thought I could draw, I thought I could paint, and I believed I had a vivid imagination but, having studied this book for the last few hours I realize I have been fooling myself. I've been living in a fantasy world. Here is the real thing … a man who draws beautifully, paints like a Leonardo, and is able to imagine worlds that I gave up dreaming about long ago. Not that I wanted to give up dreaming about them but, unable to render them as I saw them in my mind's eye, I shut them out. So you can understand my depression at being reminded of my failings.

Nevertheless, John Howe is the kind of artist the world desperately needs. An ancient pagan returned to live among us. A wizard from the North West. He looks deep into flowers. He knows their inner lives. He understands moss. He knows that stones harbour spirits. He can taste the flavour of a wind. He has felt how deep water can cut. He has seen the sky fall. Yet, with a wave of his brush, he defies gravity and tames the elements. He makes all of this real … so real that I want to dive in and never come back. I'm a child again – willing to adventure into these worlds. He makes me believe once again, that there are still heroes and great deeds to perform.

With this book he inducts us into the secrets of how he breathes life into his imaginings. He encourages us to develop the skills that will allow us to render our dreams on paper. He's very articulate. Wonderfully open and clear about the way he develops his ideas. He invites us into his studio. Shows us his techniques. Nothing is withheld. Or so he wishes us to believe. But these are clever diversions. The real secret is never revealed.

Unfortunately for him, he has unwittingly left a clue to the truth of his magical skills. Look closely at page 27. And again at page 43. Do you see it? The giveaway clue. No? Look again. Note the way he holds his stylus and pencil. Is it between the thumb and forefinger? Like a normal person? No! Do you know why? I'll tell you. It's clear as day – beyond a shadow of a doubt – that John Howe has made a pact with the devil!!!! Shocking? Yes … but true! How else could a human being create such sublime art?

Don't let him blind you with moist pages for watery skies or toothbrushes for spattering sea foam. The secret is in the way he holds the brush. I have been trying for some hours now and am slowly getting the hang of it. I've also turned off the lights and have been burning sulphur and chanting incantations to the demonic forces. I think it's beginning to work.

So, look out John Howe. I'm on your tail. I'm giving up directing movies and am going to show the world that I too can paint wonderous worlds of imagination and dreams. And I'm going to beat you, John Howe! You should have cropped those photos more carefully.

GREEN FACE
'Green faces' or 'Green Men' are one of the most fascinating, inscrutable and enduring motifs in medieval art, from Celtic forest spirit to high Gothic flamboyance.

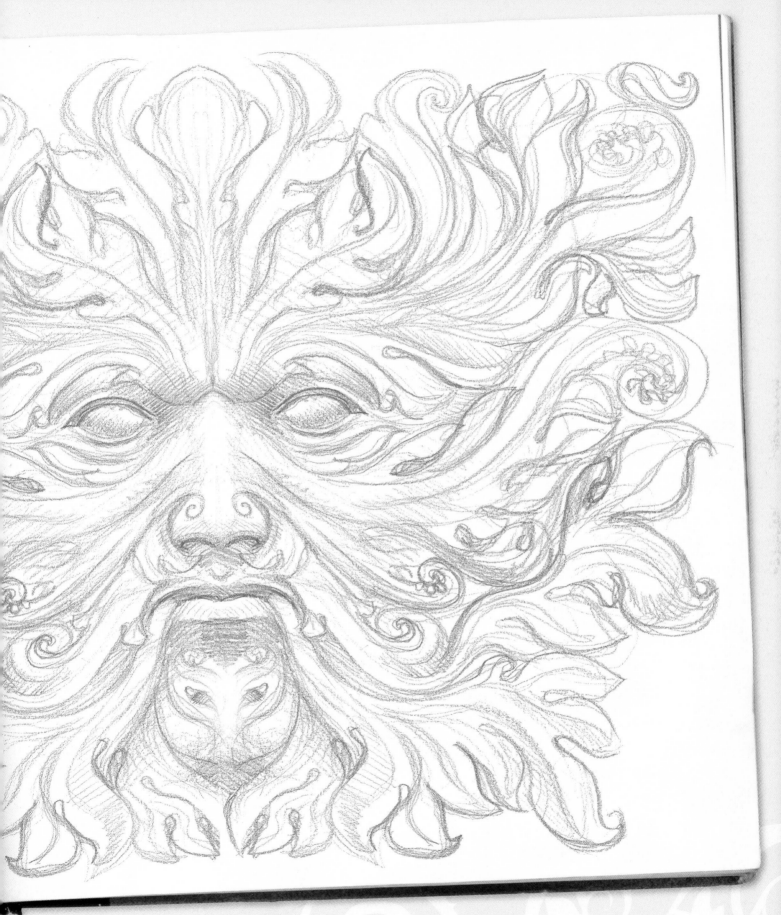

INTRODUCTION

I wanted to call this book 'How to Draw Like Me It's A Cinch Anybody Can Do It', but the editors seemed strangely reticent. (They said it was too long, so we agreed on a different choice of words.)

It's almost what the book is all about, but not quite. I will ramble on endlessly about how I draw and paint, but it's really all about how to draw like YOU. If you're reading this introduction, and wondering if buying this book would be money well spent, I'll try to save you some time.

If you know how to draw already and you are quite satisfied with the results, then this book is not really for you. If you feel that figurative and narrative imagery is dull, this book is not for you. If you feel that mythology and fantasy have little to say to our modern world, then this book is most definitely not for you. If you are searching for off-the-shelf methods and surefire technical tricks of the trade, then this book is not for you. If you believe pictures should speak for themselves, I'm tempted to tell you to buy it, because there are lots of images in it. However ...

If you find your mind is full of images and that they keep escaping from your fingertips, then this book may be for you. If you are unsure of the direction your artwork wishes to take, but know you should be heading somewhere, then this book may be a signpost of a kind for your journey. If you find pleasure in telling stories in pictures, then this book may help you. If life has obliged you to leave pages of yourself unturned, and you'd feel better with a little company for a chapter or two, then perhaps this book is for you.

I should say right from the start that I dislike most 'How To ...' books, unless they are purely technical, and concern themselves with spark plugs, hot water pipes or computer software. I dislike the temptation to reduce an intuitive and intensely personal process to a series of steps or a recipe. I am dubious about assemblages of rectangles and circles that magically turn into horses, tigers or trees. I moan when I see famous paintings divided into arbitrary circles, triangles and (fool's-) golden means.

Drawing is giving yourself up to an exercise with no immediate application. It is a form of communion with your subject, be it in front of you or in your head. Expertise and skill go hand in hand with your desire to express feelings, to tell stories, to create and share worlds. It's personal.

So I have tried to find the words to say how I feel. With each picture being worth a thousand, that makes quite a few. The editors have had to seriously cut their number, and I'm grateful to them for allowing my thoughts such unruly growth, pruning only when necessary.

NIGHTMARE CROW
This illustration for *A Clash of Kings* by George R. R. Martin is the stuff of bad dreams: one of the protagonists of the novel is plagued by a three-eyed raven that pecks at his face. I've always loved crows and ravens, but I would not like to encounter this one. Even more disturbing than the bird's extra eye are the feet modelled on human hands. It's a wonder things like this don't give me nightmares.

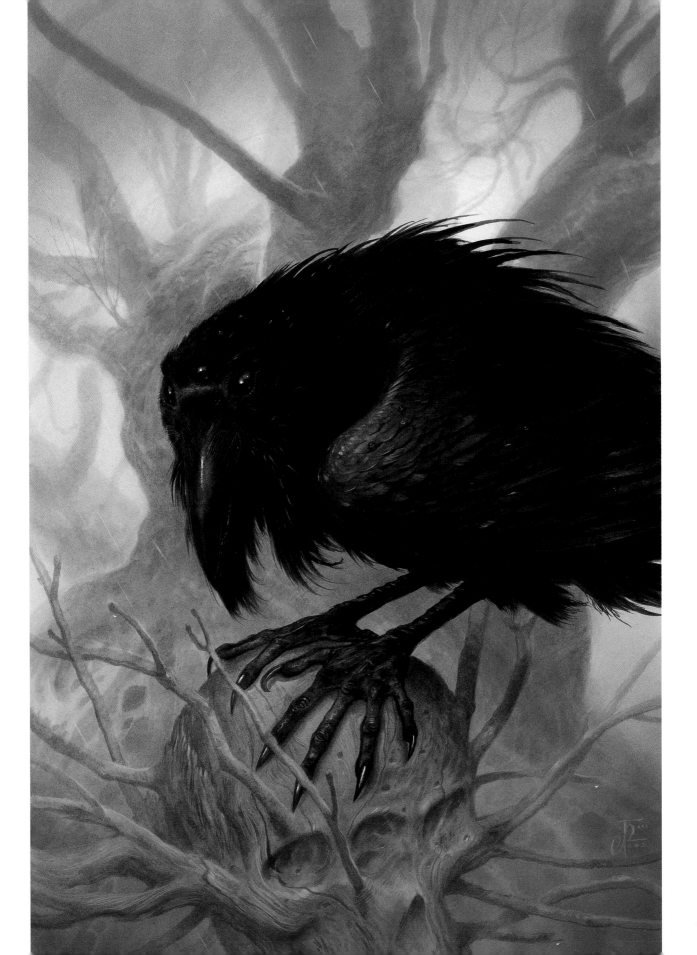

This book is personal, too. I can only speak for myself, not for illustration. Nor am I trying to speak to some fictitious potential reader. If I could, I would rewrite this book for each one of you, and include a couple of chapters of your work. Of course, this isn't possible, so I beg your indulgence.

Inside, you'll find a first section that talks about how I get along with the muse and find my inspiration (wherever and however I can); the second section is about the materials and techniques I use and how I use them (as best I can). The third part looks at a selection of my work, with step-by-step case studies that give blow-by-blow accounts of the process, and the fourth section deals with presenting your work, with a last bit about the varied fields illustration can lead you to wander in.

The case studies are the book's reality-show slice of life, complete with commissioning editors, deadlines and last-minute deliveries. I confess to having been hard-pressed to present these in a useful manner. The initial colour washes define the atmosphere and tone of most pieces, while the second stage is usually a redefining of the initial sketch and a blocking-in of volumes and forms, but from that point until the final touches, the choices are far more arbitrary. I've tried to include episodes of significance, but making an image is a three-way conversation between the idea, the artist and the emerging work, and it can take unexpected turns. Many pictures go through phases where they are unattractive and laborious, so I've singled these out too, since they may not be pretty, but they are instructive. The very last stage is the adding of light and highlights, the final injection of life into an image before you make the final step – and the first – away from one picture and on to the next.

Finally, to my comrades-in-art and fellow illustrators, I beg your indulgence for this foray into the dreaded land of Explanation and the perilous realm of Reason, momentarily forsaking the foggy shores of Inspiration. I am speaking only for myself, not for my profession. All of you have your own voices. (But buy the book anyway.)

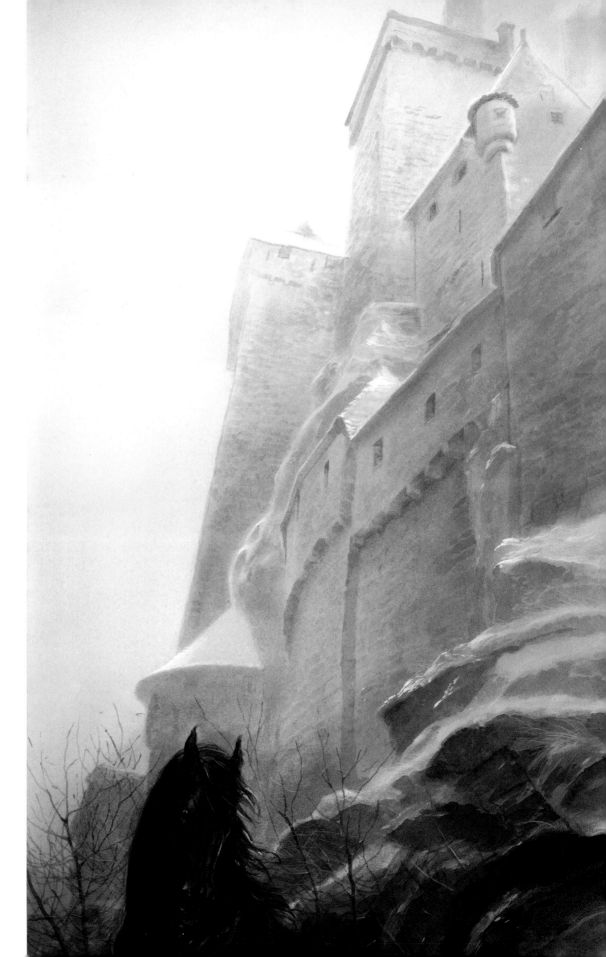

THE FORGED HORSE

Back cover illustration for *The Golden Fool*, Book II of *The Tawny Man* by Robin Hobb. This castle is one I know very well and have visited frequently. The ability to go and walk around places like this is perhaps the main thing that keeps me in Europe. (It is certainly more revealing than typing 'castles' into an internet search engine.) On first arriving in France 25 years ago I fell in love with the millennia of history present everywhere, and that sense of wonder and inquisitive interest has never dulled. Occasionally, real places seem to find their vocations in works of fiction with little change. This castle has become a fundamental piece of architecture in the Robin Hobb trilogy. In addition, its collection of furniture provided a significant portion of the furnishings in Bag End for the *Lord of the Rings* movies.

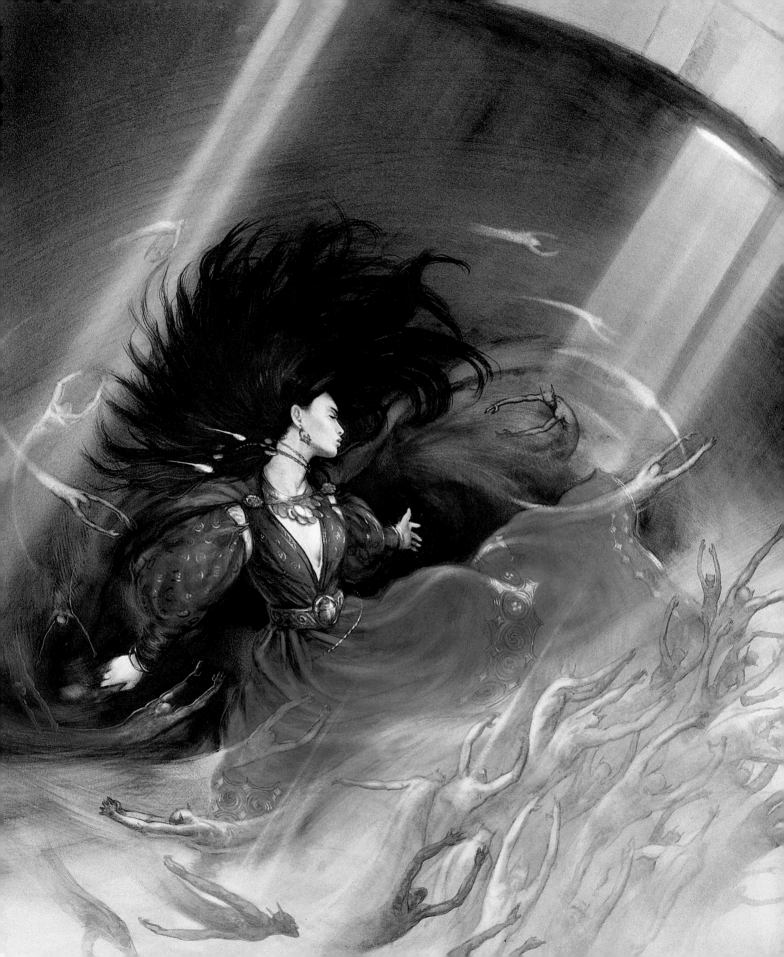

THE CREATIVE PROCESS

Where does inspiration come from? Or, more importantly, where does it go when you just can't find it?

It is wise not to confuse information and inspiration. The former is the result of studious application, the latter is what happens when you don't think about it.

Each has a role to play, but must not look to play the role of the other. Inspiration may be the bright tower in the clouds; information is the solid rock where the foundations are.

NARRATIVES, THEMES AND INSPIRATION

I spend all my time being shocked and delighted at how beautiful things can be – light, waves, rocks, faces, architecture, stories, music, whatever. All this beauty makes me feel vulnerable, because it's perfection far beyond what I can ever hope to render, but it also makes me burn to try.

I see compositions, translucencies, light, shadow, things sharp and things hazy, always things that can make pictures. Inspiration is like breathing, and it's no surprise these two words share an etymology. Many people ask where inspiration comes from, and I think it comes down to worlds – three of them: the one in which we all live, the world of words we are enticed to enter, and the world somewhere between the first two, where images are. This third sphere is the secret one, the walled garden where the carefully tended flowers blossom, or the blasted heath where the cauldron steams and bubbles. Pellucid or adumbrate, cluttered or spotless, it's the place where even your closest friends can't go. But you can wander about there and return with the travel pics.

Fantasy illustration has been going on for centuries, but the notion of literary fiction heralded a shift of perspective, and consciously conceived fantasy literature is not that old. I often wonder how Chrétien de Troyes would have described his Arthurian works. So what makes fantasy 'fantasy'? I think it has something to do with our distance from the subject. When fantastical creatures were part of the common culture – devils dancing in a hellmouth, for example, or a world-encompassing wyrm – the artist was giving visible form to a reality shared by the viewers. When an artist is illustrating a cycle of legends, however meaningful, the viewer's perception of the images is not the same. It's a rather subtle and ultimately savoury paradox that the ousting of fantasy from the everyday has resulted in the erection of its modest pedestal.

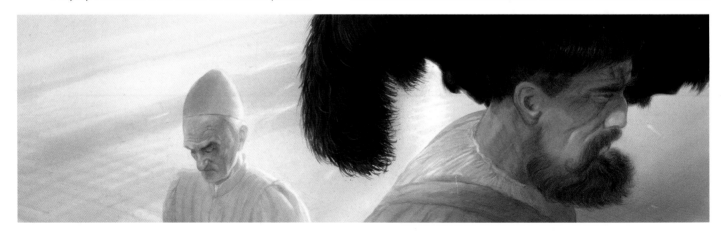

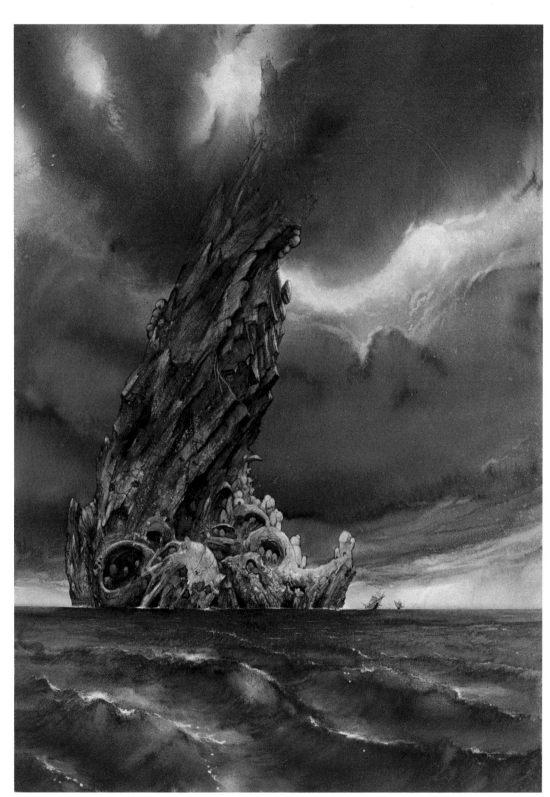

THE NAMELESS ISLE ▶

This image was painted in art school. It is based on an episode from H.P. Lovecraft's novel *The Dream-Quest of Unknown Kadath*. A classmate had a huge collection of small animal skulls that one day we piled up and photographed. Those pictures led to this image, which subsequently led to 'The Dark Tower' in the 1991 Tolkien calendar, and finally to New Zealand, to a rather larger version of the same ... Which just goes to show that teenage obsessions can go a long way.

◀ **BONE CASTLE**

Typical of the exercises done in art school, this was going to be an ambitious composition – if only I had ever got around to finishing it ... The school possessed some extravagantly exotic animal skulls. The little castle is perched on the jawbone of a hippopotamus.

◀ **THE KING AND THE GLASSBLOWER**

Illustration from *The Abandoned City* by Claude Clément. The profile of the king is from a book of stock imagery with a beard and hat added, and the glassblower is my wife's father, who obligingly posed for all the portraits of this character.

The King and the Glassblower, from *La Ville Abandonée,* John Howe © CASTERMAN S.A

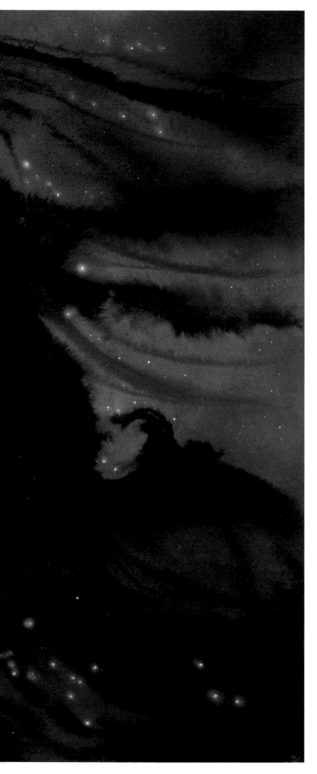

Myth and legend is the arena where humanity carries on its most enduring struggles, and I would like to think that even modern fantasy illustration can be a part of that. Of course there is an element of pleasure in it, but it can also be a way of proposing a path of thought or stirring an emotion that may lead to resolving personal issues. There are dragons within and dragons without. Fantasy illustration should be a lantern that tries to shed a little light on things, not just posters for teenagers' bedrooms.

The difference between iconography and narrative imagery is like the difference between a photographic portrait in which the complicity of the subject and photographer is evident and one where the subject seems unconscious of the camera. With photography, it's a given that both artist and subject belong to the same world, but with fantasy art, we are looking through to another world. It becomes really intriguing just where the regard

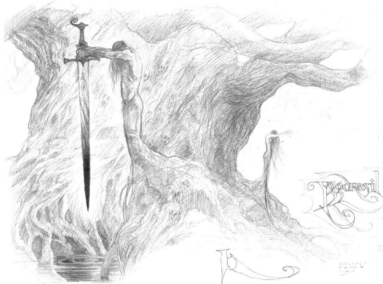

◀ DRAGON OF CHAOS
After the Babylonian god Marduk slays the dragon Tiamat, he builds the world from the smoking ruin of her body. A protean, dissolving form seemed to best express time before time. I worked up the lighter parts on very damp paper, then dropped a *lot* of black with an eye-dropper, and coaxed it into shape with a feathered brush as the colours ran. The stars were added in white acrylic, airbrushed to make them shine.

▲ YGGDRASIL
Isn't this a grim drawing? What *was* I thinking? It started with the sword hilt then grew into a tree with the figures below it. Occasionally a word or phrase can trigger sketches that go far astray from the original idea, often leading to new ideas. Following your pencil as it wanders is often more rewarding than pushing forcefully before you.

NARRATIVES, THEMES AND INSPIRATION

of the subject stops short of actively engaging the spectator. Characters can look directly at the viewer without the gaze actually leaving their universe, allowing the looking glass to remain intact. Unlike 'poster art', fantasy illustration should open a window on another world, rather than clothing our own in fantasy trappings.

Before the era of mass media, any encounter with art would have been more rare and significant than it is today. Modern life has pruned away many of the uses of enchantment (to quote Bettelheim) and science has explained many others. So in a way, fantasy has left the wider world to find a home inside our heads. We project our fantasy outwards rather than encountering it in inexplicable phenomena. Nowadays, fantasy is largely a solitary game, though with the complicity of many in the case of a popular theme such as *The Lord of the Rings*. This makes the 'validity' of the artist's vision an issue: it must convince the viewer, since what things look like is now a personal rather than a cultural choice.

I think the 'personalizing' of fantasy goes hand in hand with our freedom of choice in modern society: with our 'smorgasbord' approach to spirituality and philosophy, it is often relegated to the

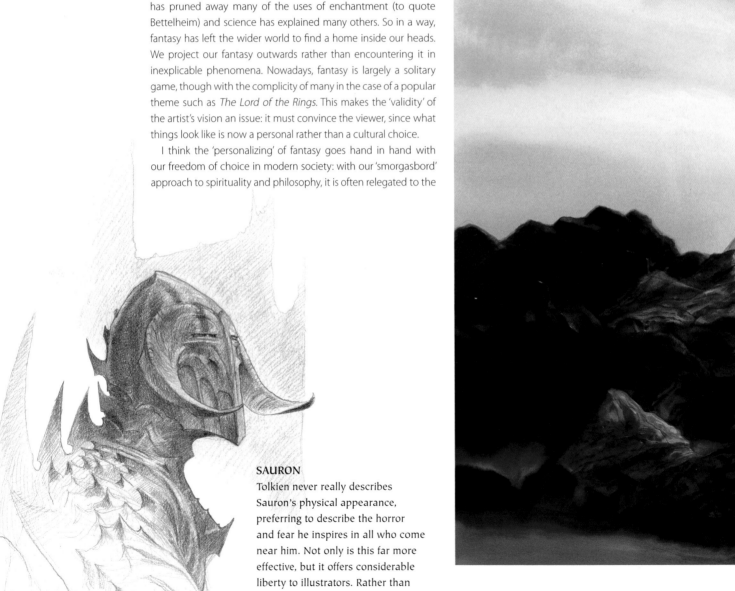

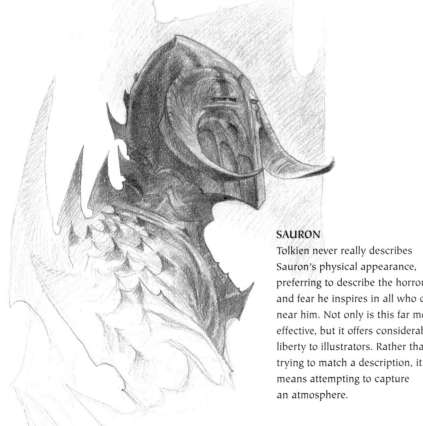

SAURON
Tolkien never really describes Sauron's physical appearance, preferring to describe the horror and fear he inspires in all who come near him. Not only is this far more effective, but it offers considerable liberty to illustrators. Rather than trying to match a description, it means attempting to capture an atmosphere.

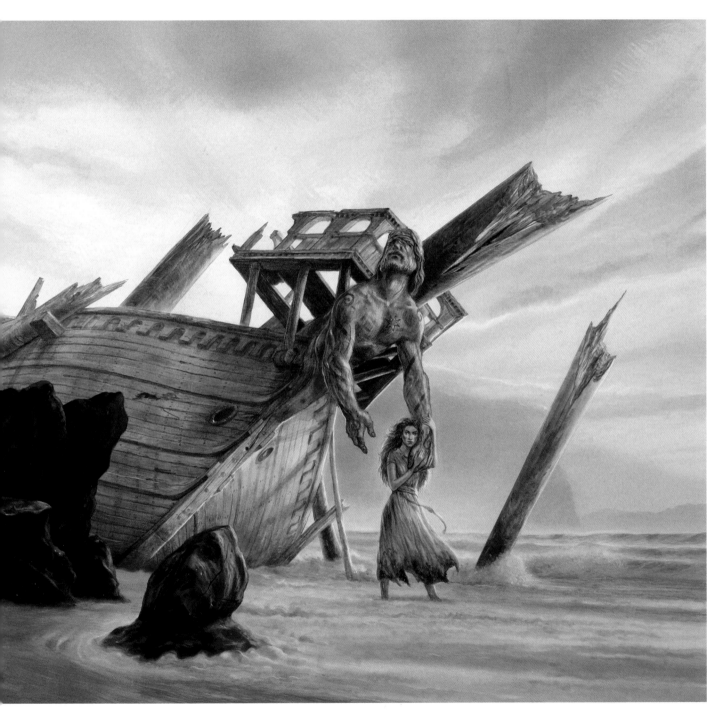

THE MAD SHIP

Illustration for the cover of *The Mad Ship* by Robin Hobb. This story features a seafaring merchant people who have most unusual ships: the figureheads are far more than wooden effigies – they are alive. The mad ship lies rotting on the shore, his eyes blinded by axe blows. He is befriended by a ragged beggar girl. Mismatched and crippled friendships are always moving.

NARRATIVES, THEMES AND INSPIRATION

world of distraction and entertainment – literature, film, games. But dragons may not yet have breathed their last. In many ways, we are not so different from the people who invented the myths, and, as myths are always invented for solid reasons, fantasy does have a contribution to make. Ancient beliefs have been the richest source, drawing on the mythology of the ancient Greeks, Celts and other cultures. And the line between religion and fantasy is not cut and dried: religious symbols such as the Grail are rampant in what we now call fantasy, and on the edges of belief roam fantastical creatures such as gargoyles and dragons, which are part of the history of religion.

For me, fantasy imagery involves 'glamour' (in its archaic sense of enchantment), and implies a suspension of rationality. It refers to worlds and creatures derived from myth or invented by creative minds in the same vein. Its fully realized worlds have elements that we cannot physically experience – they are generally pre-industrial, slowly blending into science fiction as they move forward in time, trading suspension of disbelief for belief in the promises of science. Teleportation, for example, is magical in a medieval setting if done by a mage, but it's sci-fi on the Starship *Enterprise*.

Awe is not enough, there must be something in fantasy that is beyond our grasp. It is about empowerment: the shedding of the mundane, the pruning of the everyday and the transposing of human preoccupations into an environment where the 'possible' reigns, coupled with a richness of imagination and a common cultural inheritance. It is something we should never grow out of.

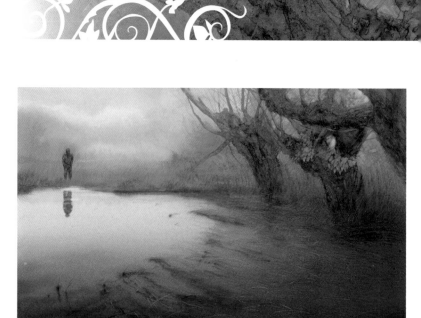

▲ THE POND

This painting was an illustration for *Rana-la-Menthe*, by J. L. Trassard, a sad tale of a solitary poacher haunted by galloping hoof beats. One moonless night, he manages to stop the horse, which is ridden by a beautiful yet silent woman. Of course, she is not human and eventually returns to the marshes, leaving him disconsolate. I wanted to show how the world that was once a refuge is now a barrier between him and his lost love. The unfathomable pool and dragging weeds, overshadowed by brooding willows, are the result of this line of thought.

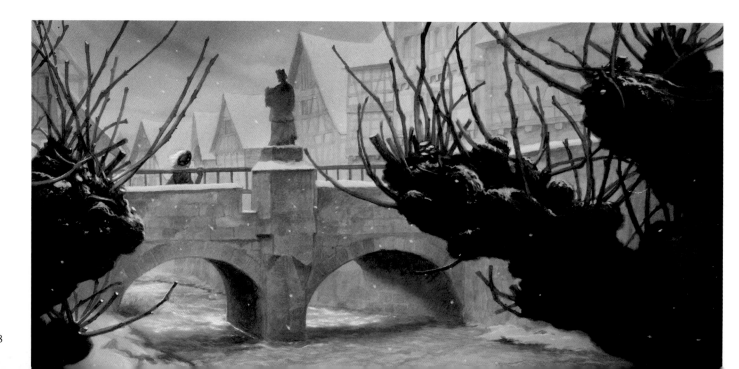

CASTLE FANTASTIC

This painting was done for a book cover. Theme: castles; angle: fantasy. I recall using miles of tape to mask the various receding ramparts – pictures like this are quite strictly regimented undertakings. In terms of inspiration, I would call it a sort of 'incestuous fantasy': vaguely exotic, orientalist architecture without a definite direction. It's not a painting of which I am terribly proud – I find it too generic – but it has been *very* popular.

◄ THE MAN WHO LIT THE STARS

The bridge in this illustration for a children's book by Claude Clément is taken from a town in the Jura, the buildings from another town in the Alsace, and the pollarded willows from across the lake where we live. (They feature in many of my illustrations.) Actually, my only addition to the scene is the man with his ladder. (The ladder, by the way, allows him to climb up high enough to clean stars, so you never see either end of it until he reaches the top.)

The Man Who Lit the Stars, from La Ville Abandonée, John Howe © CASTERMAN S.A

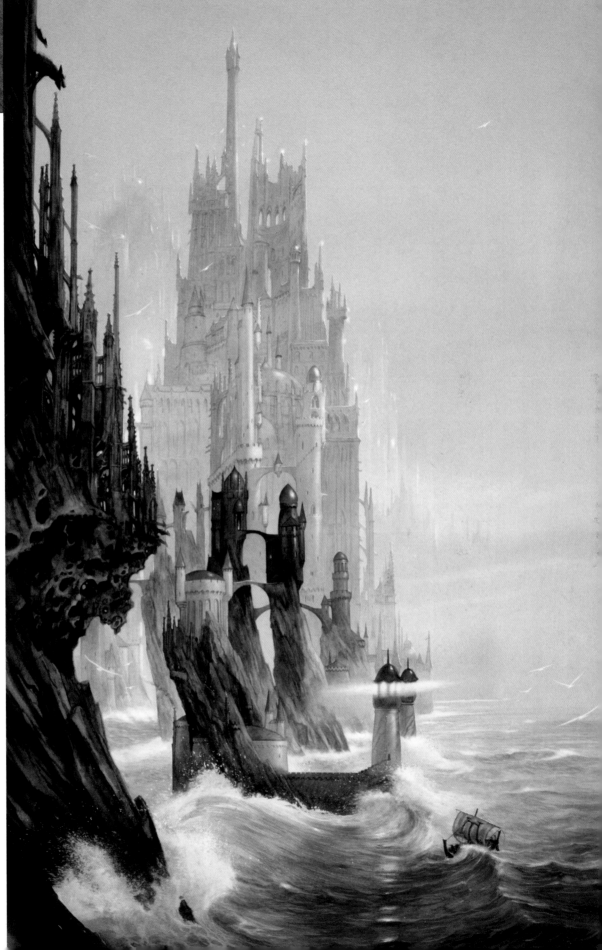

GATHERING AND USING REFERENCE MATERIALS

Being something of a magpie is a useful quality for any illustrator. Gathering material, whether you store it in your head, in your sketchbook, on your computer or in a folder, is essential. (Organizing it so that you can find it when you need it also helps.)

To anyone who is keen to convey a certain sense of reality in fantasy, reference materials are crucial. Our house is full of books in languages I can't read, purchased exclusively for their images. (I only read the pictures in most of my books anyway.)

The wall behind the computer supports a daunting set of shelves containing well over a hundred drawers, filled with photos, photocopies, and pictures cut out of books and magazines. Here, from top left to bottom right, is the whole list of categories: medieval graphics, postcards, medieval calligraphy, medieval tapestry/embroidery, medieval lamps and lanterns, medieval iconography, medieval costume, men-at-arms, 1515, 1476, to be filed, mode, illustrators, food and flowers, urban landscapes, Middle Ages & Co, medieval artists and scribes, manuscripts/arts, sculpture/decoration, myth and legend, medieval gloves, medieval fun and games, medieval pottery and potters, medieval craftsmen/ merchants, ships and navigation, heraldry, medieval furniture/ interiors, medieval households/utensils, other places, other times, children, medieval folders, campaigning, medieval urbanism/ maps, peasants, medieval footwear, objects, walls and frescos, art and paintings, all that glitters, industrial medieval, battlefields, art objects, Mythago Wood, outer space, cool stuff, faraway places, places south, deserts, the roof of the world, spiders and bugs, horseshoe crabs, bats, bulls, carapaces, machines, flying machines, ships and boats, ravens, rhinos, ruins, rust, skulls 'n' bones, Canidae, birds of prey, birds, fishes, Ursus, barnyards, Felidae, animals, faces, beards and wrinkles, hair, cloth/folds, Celtic, King Arthur & Co, PRB & Co, Beowulf/Odin & Co, wyrms, trees, more trees, waterfalls and rivers, waves and oceans, landscapes, LOTR movie stuff, Middle-Earth, Yggdrasil, brambles/ivy and leaves, horses, smoke and fire, skies/storms and clouds, mountains, more mountains, rocks, more rocks, yet more rocks, ice and snow, calm waters, landscapes, orcs and such, knotwork, Haut-Koenigsbourg, bridges, castles, Romanesque, towers, gothic, urban gothic, bodies: female, faces: female, bodies: male, hands.

My filing system would make a dedicated documentalist faint in dismay, but remember, I'm the only one who uses it. (It is entirely visual, and I must say that only an intensely creative mind would call three successive drawers 'rocks', 'more rocks' and 'yet more rocks'. It is also extremely handy when film crews and photographers invade the studio: I can helpfully place around the illustration in progress a few dozen photos that have nothing to do with the picture at hand. 'Um, can you tell me again, Mr Howe, about the importance of thorough documentation?' the reporter asks, throwing puzzled sidelong glances at the photos of tropical fruit that surround a partially painted Balrog.)

Imagination cannot function in a vacuum. Faced with the hopeless ideal of memorizing everything I see, and blessed with a

Out searching for things like a table and chairs and other basic furniture years ago, my wife and I stumbled on this beautiful (and wholly unnecessary) stuffed raven. Of course we bought it immediately.
I don't really use it as a model, but it does constantly remind me of the complexity and beauty of real creatures.

▶ A little bit of everything, from medieval armour to movie props. Fantasy illustration can happily benefit from the authenticity of reconstructed accessories, not necessarily for copying outright, but to gain a sense of proportion, weight and feel. The raven's foot, just behind the spare arrowheads, is a prop I use often (see page 59). Grendel's mother (page 50) is the latest beneficiary. Narsil (bottom right), by the way, is, to my knowledge, the only movie sword ever designed with a hollow pommel.

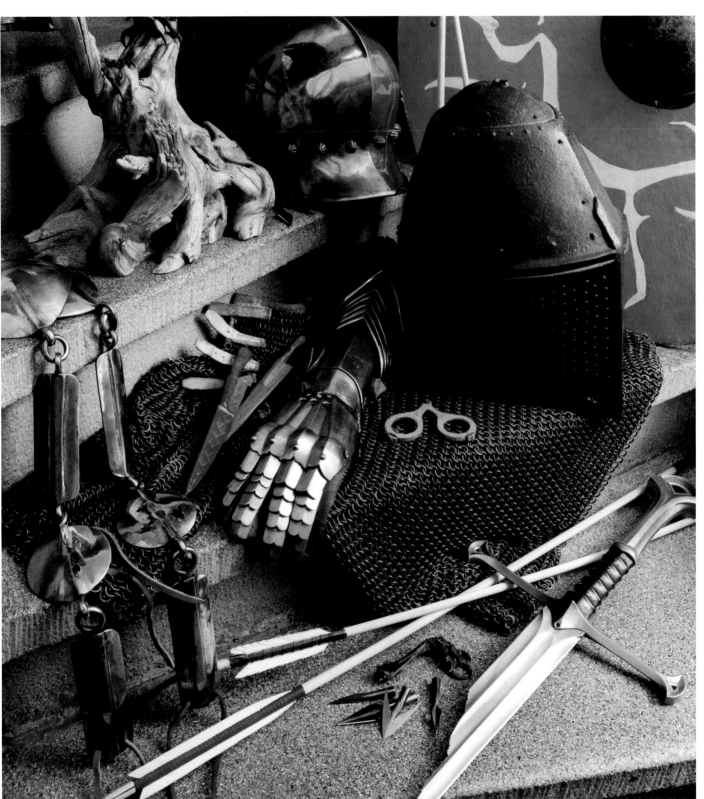

GATHERING AND USING
REFERENCE MATERIALS

squirrel-like tendency to store things away just in case, I stack my reminders away, rather like the forgetful actor who knows he can count on the prompter to jog his memory.

However, this kind of reference is to be used with some care. Unless a particular photo coincides so closely with the germination of an idea that the two are intertwined, the sketch must always come first. To invert the order is to make an error that will, if it does not compromise the spirit of an illustration, indenture it to the document and misdirect the focus.

We are all happy picture-snappers of the instant camera age, where our perception of the world is often (over-)defined by the speed of a shutter. The superiority of sketching over the camera resides in the nonchalant pace of a sketch, which paradoxically stops time, permitting a look that can stretch over many minutes, even hours. An out-of-time communion, subject to passing clouds, the movement of the sun, failing light, it is the antithesis of the snapshot. Photos have a role, but a subordinate one. Their wealth of detail and colour masks the fact that they are incomplete, and can easily end up being 'hollow' – all surface, no substance.

Obviously, the constant accumulation of imagery is not enough. Good illustrations are not done with the copy/paste function, nor do they have anything to do with a lavish laying-on of detail. The value of information and knowledge, visual or other, is the time it spends kicking around inside one's head. The mind is not an idle place where things are stored away collecting dust. They talk to each other, exchange information, get together, make groups and friends, and eventually are there when you are doing the one thing you cannot do consciously – being inspired.

It's easy to confuse information and inspiration, and it can be fatal to the latter. Sometimes, the bulwark of documentation can wall you in and kill any spark of creativity. On the other hand, one word can unlock the door to a vastness of options: when I think 'window', I want the full history of the window through the ages and the world over to flash before my inner eye – pueblos and step gables, arrow slits and solars, from Mycenae to my neighbourhood, from caverns to cathedrals; the whole lot to borrow and invent from. What one draws so often relies on recognition and not observation, an aggregation of recognizable elements, not real invention.

However, I do know that somewhere in the drawers on mountains are the images that will take me to Asgard or Shambala, that Yggdrasil or Avalon are also tucked away somewhere, and that if I pay attention to the pictures, I'll get there eventually. Somewhere in this accumulation of anecdote are the signposts pointing out the path to the universal. That's what myth is all about.

▼An unstable rampart of books and documentation usually piles up around my table when I am working on a project, its height depending on the number of elements involved in the work at hand. File drawers, books, photos and clippings wash up around me like flotsam on a high tide. They are naturally put away when the picture is done, but a certain healthy disorder in any studio is recommended, even mandatory.

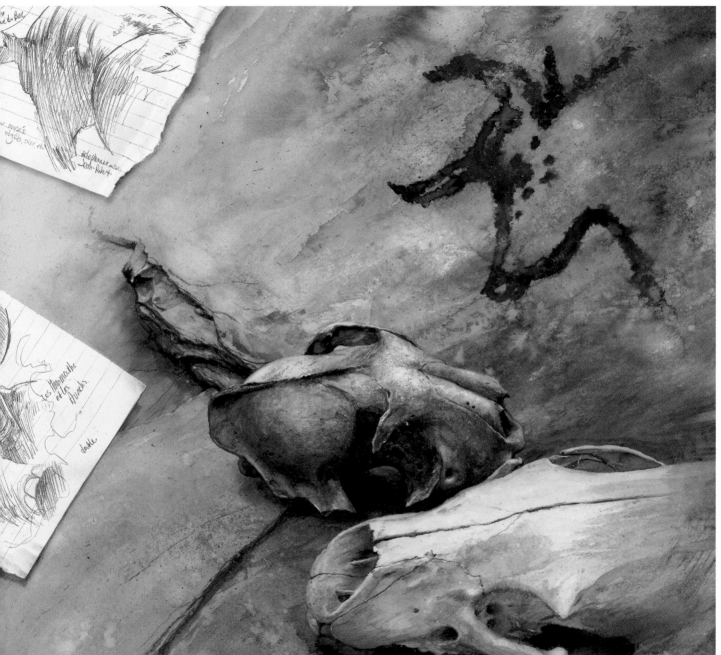

THE QUEST FOR FIRE

This illustration was for the endpapers of J.H. Rosnay's epic caveman saga of 1911, a prehistoric western adventure of sorts, with sabre-tooth tigers, warring clans and of course fire, a precious treasure to be saved at all cost. Endpapers are the perfect place to indulge yourself, as they have no narrative context, and remain purely decorative. The ballpoint pen sketches are taken from a tiny sketchbook I was using at the time, the animal skulls are from my small collection, and the cave painting is from a book on Lascaux. The paperweight is a primitive fire striker from a museum catalogue.

ORGANIZING YOUR WORKING ENVIRONMENT

A comfortable working environment may be every illustrator's dream, but this is not always possible. The most important element is that it is *your* space for *your* pursuit of imagery, whether it be the size of a broom cupboard or a loft – you must be able to leave your things and not have to clear them away every night for dinner or TV.

Whether you work in your home or out is a personal choice: I have become so accustomed to the intermingling of professional and family life that I no longer feel qualified to judge what works for others. But while illustrating is of course a job, it is also a waltz with the muse, and a sudden inspiration should not have to wait while you drag your art materials out from a cupboard and set them up.

It also helps to have themes and interests continually bouncing around inside your head: keeping in mind all the things you have found interesting recently, and why you found them interesting, will often provide material for a drawing.

Choosing a place to draw

Where you choose to work largely depends on how you habitually draw: a lot of people would be surprised to realize how many drawing reflexes they have inherited from writing – sitting at a desk, with the lamp just so, the chair at the right height and so on. (When I say 'draw' here, I really mean 'sketch'; finished images are a different matter.)

Drawing is rather like fencing – you need to master the correct skills when using pointed instruments – and you must control the distance between you and your sparring partner. If you are not yet sure of your proficiency, placing the paper on a table can plunge you back into a 'scholastic' situation more adapted to writing than drawing. For sketching you need to loosen up, sit back, get your arm free from the shoulder down and let your pencil wander. When I see people studiously sketching with an HB pencil, heel of hand firmly planted on page, working in a square centimetre of space, I want to yell at them.

Moving on

Given the materials involved, finished artwork is a little more cumbersome, but by the time you reach that stage any hesitations and 'blank paper block' should be gone, swept away by the ideas you've sketched. You do require a personal space for this, but itinerant colour work can be done quite easily if you have to.

Getting going on a big piece may require a certain ritual, exploiting every opportunity to procrastinate – I generally tidy up the studio, rearrange things, vacuum the floor and do something else totally pointless that could wait, and finally, when I've run out of options for wasting time, I'm just about ready to start. Beginning a piece requires a heightened level of attention and awareness to get the first colours down right, and this initial hurdle needs to be taken at a certain speed. If you confuse the two – the blank-page musing and the actual starting – you may run into sometimes insurmountable obstacles. If you have drawn something once, on any surface, you can redraw it for your finished piece. If you have the feeling that you'll never be able to draw it again as well as you just did, you are only on the very edge of your achievement, and you have not really drawn your idea but only approached it.

Redrawing is the only way to maintain the spontaneity of line necessary for the germination and elaboration of ideas and the integrity necessary for colour work. You are far more free to make errors in a sketch and correct them later than if you endlessly erase and re-erase small details on a piece of work that is neither a sketch nor a finished artwork. Separating the two notions, and their inherent contingencies, allows you to work pretty well anywhere.

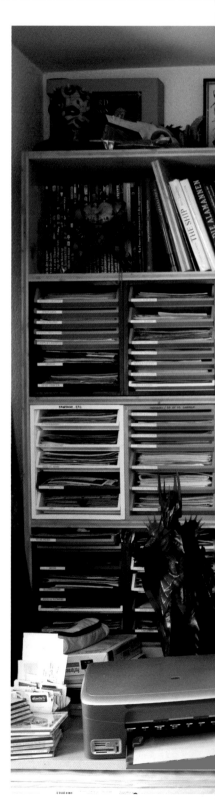

▶ I refer to this as the high-tech end of the studio (the rest is resolutely low-tech), with computer, scanner/printer, files, documents and telephone. The books can be in any language, as long as they have the photos I'm hunting for, and many others overflow their shelves in various parts of the house. Just visible on the right is the current year in the form of a massive hand-drawn calendar, each day the size of a Post-it, which lets me (try to) keep track of my life.

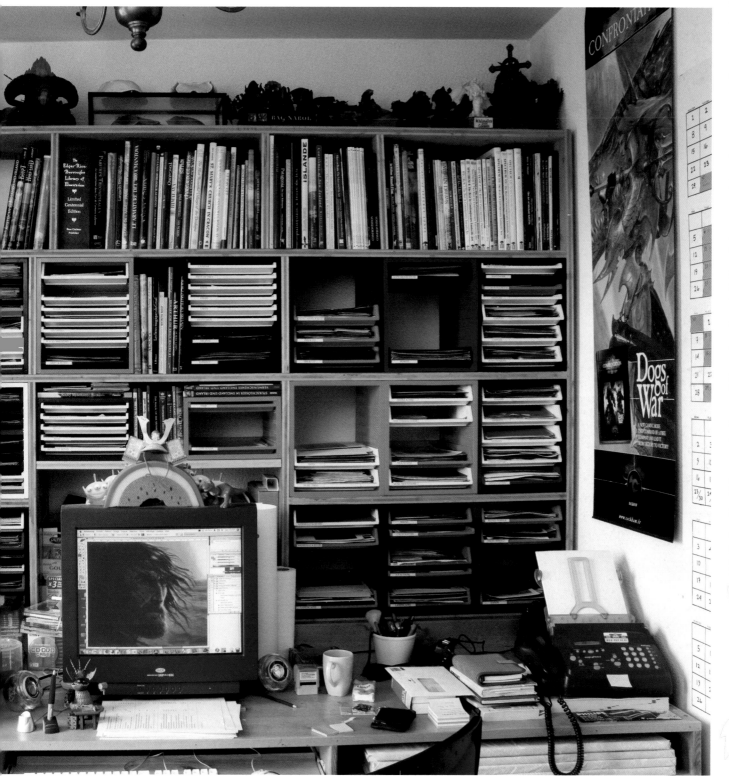

PROTECTING AND STORING YOUR ARTWORK

T he main enemy of finished artwork is light, particularly ultra-violet light. There are plenty of ways to protect against this, the easiest being to store your work in the dark – by which I don't mean archiving at midnight with the light off, but putting it in folders, boxes or drawers (a plan chest is best).

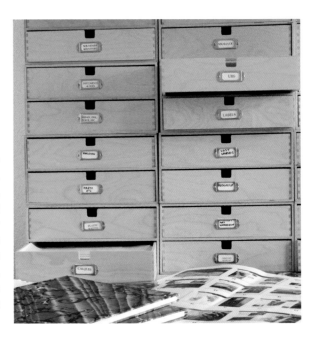

Ultra-violet (UV) light eventually makes any paper yellow and decay, and alters pigments. The most durable medium is egg tempera, which is practically indestructible. Oil paint comes next, pastels and watercolour after that. If you want to display your work, it can be framed with UV filter glass, or given a light coat of fixative containing a UV filter. The other enemy is humidity, and this is a matter of storing your work somewhere that isn't damp and hopefully won't flood.

Using fixative

Pictures do not have to be covered with fixative to survive well, but it is a practical expedient against damage caused by greasy fingers, stray drops of water and general handling. If work is stored and handled competently, it shouldn't be necessary to spray large amounts of fixative on it; but if you do use fixative, the rules are to put as little as you can on a picture beyond the colours, and to use two or three light coats rather than one thick one.

Pastels cannot be fixed, and demand special care; watercolours don't really need to be fixed, but other drawing media can usually do with a coat. I generally put a spray of fixative over the pages in my sketchbook, as all the travel tends to result in wear and tear, and I put a sheet of tracing paper over every original drawing.

Digitizing images

Scanning images can be fraught with frustration and annoyance, as well as costing a lot. The cheapest machines are flat scanners, but their tolerance for the thickness and rigidity of what goes through them can vary, and you're better off with paper than board. Any decent scanning service will allow you to scan on a photocopying machine, as long as this is set up properly – I do my A3 scanning, both colour and black and white, this way, and calibrate the machine myself.

When you are using a scanning service, make sure you are shown the scan at full size on a decent screen before you accept it: scanners can develop glitches, and suddenly you may have a red or blue line two or three pixels wide running the length of your picture. Large scanners are often two machines running in tandem, which means that the image is 'stitched' together around the middle – check that there are no problems with this. There is also a tolerance point where the pixels drop out for very light surfaces. You should have some colour, even a tiny percentage, pretty well everywhere, and no blanked-out white areas.

If you have image-editing software at home, you can prepare and rework your scans. You may also want to re-balance colours and clean an image up a little, but the essential thing in this case is to have a decent scan to start with.

Alternatively you can photograph your work, but you need studio quality equipment to do this, otherwise even a 10-megapixel shot may not give you the results you are looking for. One option is to go to a professional photographer who has the required lights, studio space and so on, but this can be expensive as you will be charged for the time spent setting up. So if you go down this route, it's best to wait until you have a group of pictures to be photographed, so that the same set-up can be used for all of them.

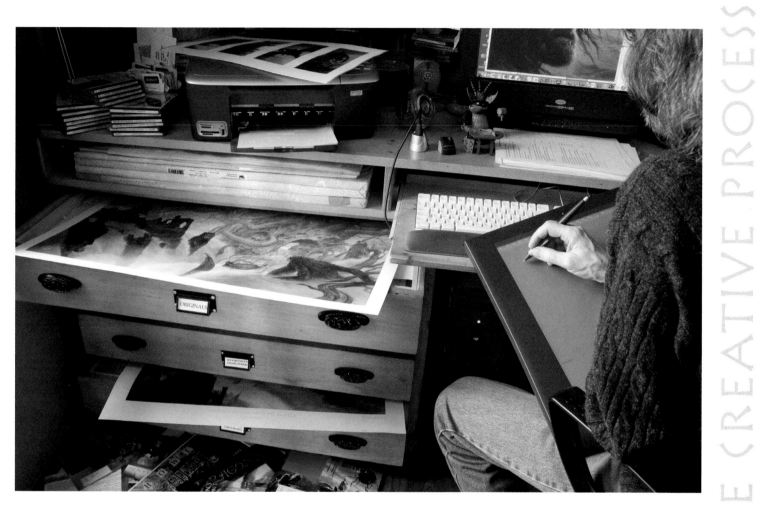

The plan chests in my studio have drawers that are a little deep, so I've installed an extra tray in each. While originals live in the plan chests (I prefer not to have them on the walls – I've already seen them), digital files are generally stored on CDs (which have edged out my music CDs due to lack of space) and on separate hard drives. I normally use the graphic palette seen above for tidying up scans of artwork.

For years I vainly attempted to classify my documentation in binders, but if searching for a reference was laborious, returning it to its proper place was pure torture. So I abandoned binders for drawers, which largely compose themselves. Documents that are rarely used tend to sink to the bottom like sediment and may eventually be discarded.

MATERIALS & TECHNIQUES

Somewhere among the myriad pencils, brushes, papers and computer programs available are the particular tools you need. No two illustrators have the same requirements, and buying the trademark watercolours of some name in the art world will not help you paint. This section lists the material I use and how I use it, in the hope that it will help you find your own tools and methods.

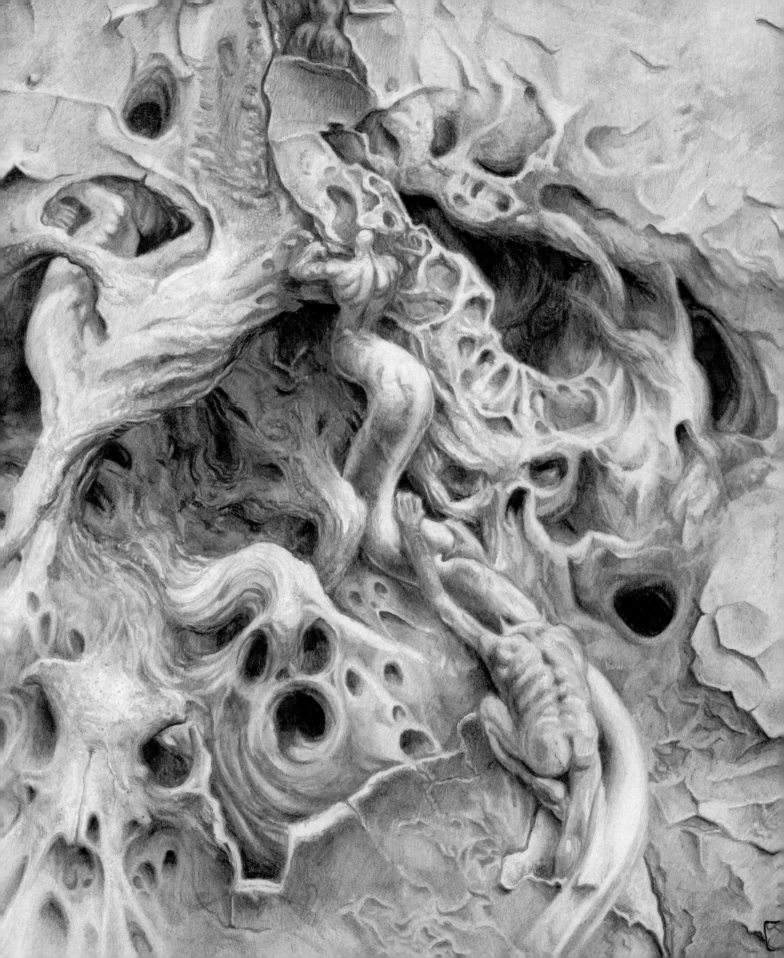

DRAWING MATERIALS: SKETCHES, SKETCHBOOKS

rawing can pretty much be done with anything you can hold – from a pointed stick to a digital tablet stylus.

Basically, you can hold your pencil any way except the way you hold it to write. While one pencil pretty much resembles any other, for sketching I tend to prefer a 4B. The lead is sturdy enough to sharpen to a needle point, yet soft enough to leave a light line on the page using only the weight of the pencil itself.

QUAY HEADS – SKETCHES
Doing variations on a theme is pure enjoyment. Often a slight adjustment in a proportion will lead to an entirely new concept. (See page 69 for the truly novel genesis of the idea for these heads – proof if it is needed that inspiration often strikes unawares.) 'Quay' © Decipher Inc.

QUAY MOTHER SHIP SKETCH
These sketches were done for a collectible card game for which I had to design an alien race. I imagined the 'mother ship' as a continually growing structure – a helical space hive with thousands of tiny attack vessels nuzzling up to the softer underbelly.
'Quay' © Decipher Inc.

◀ THE URSCUMMUG

This quick thumbnail sketch
was initially done for the
cover of *Mythago Wood* by
Robert Holdstock, and depicts
one of the more disquieting
characters from the novel.
(It was turned down in
favour of the rather more
appealing personage on page
97.) Naturally, it went into
a drawer and I eventually
finished it off in Painter on the
computer. One day, I hope to
do the colour version.

RED NAILS – SKETCH

Conan is pretty much the
archetypal action hero, so a
sketch like this is all about
keeping the tension inside the
frame. (It is also advisable to
draw all figures fully, even when
they are half-hidden behind other
elements, or proportions easily go
astray.) It can be difficult to retain
the reckless, nervous energy of a
loose sketch when proceeding to
the final version. This sketch was
actually done on several layers
of tracing paper. Occasionally it
is easier to lay a new layer over a
partial sketch, enabling you to carry
on in a new direction while retaining
the elements that function, rather
than redrawing the entire piece.

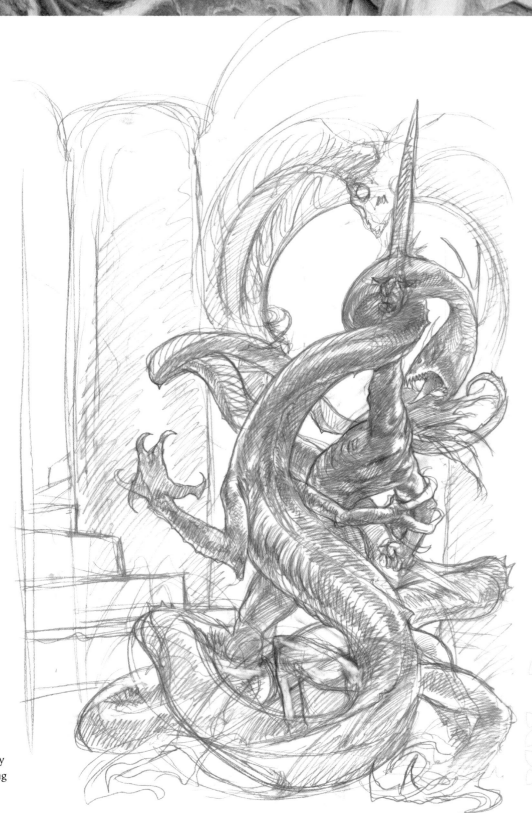

DRAWING MATERIALS:
WHAT I USE

What a truly marvellous invention the pencil is! First mass-produced in the late 1600s, modern pencils date from around 1795. They are the perfect low-maintenance method for putting thoughts and ideas on paper. Their erstwhile companion, the eraser, was invented in 1770, rather an improvement on the fresh kneaded bread that was used prior to that. I go nowhere without pencils, a craft knife and an eraser.

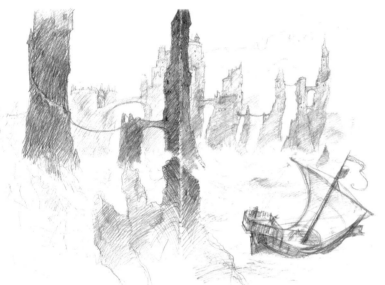

THE PYKE – SKETCH
One of the initial sketches for the cover of *A Clash of Kings* by George R.R. Martin: the Pyke is a series of castles built on impossible pinnacles overlooking the sea, rather as if the Cliffs of Moher in Ireland had been redesigned by a fantasy artist.

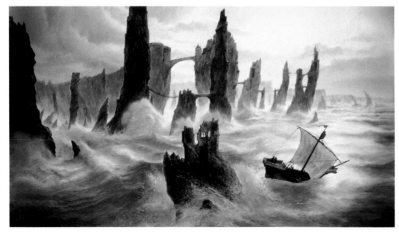

THE PYKE – FINISHED ARTWORK
The finished artwork involved using a lot of masking fluid for the waves and spray, working forward from the far distance in superimposed layers. It is wise to run a light wash over even the whitest wave tips, to eliminate the flat neutrality of the white paper.

Graphite pencils

For work that needs to be in black and white, and for sketches, use a 3B or 4B pencil and nothing harder. It is not forbidden, but for sketching purposes a hard pencil will slow you down. The softer-grade pencils are essential for freedom and looseness when you are drawing, but so many people are so accustomed to pressing down hard with pencils (the fault of writing) that they think a soft pencil will break.

You hardly need more than the actual weight of the pencil to make a decent line on the paper. Putting weight on the pencil means that it and the paper are not giving you any feedback, and your line will lack that serendipitous quality that leads to further ideas and new sketches.

If you want to do photorealistically detailed work, get a good set of pencils from 9H to 8B and painstakingly work through them in that order. For a pencil rendering of this kind, you're best off with satin-smooth paper.

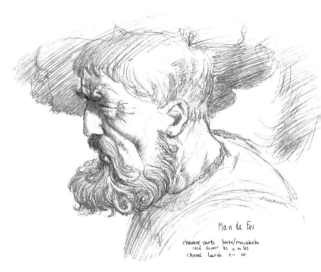

THE KING
A drawing done from one of those catalogues of stock portraits that look so useful. (All I added was the beard, hat and clothing.) But it's the only time I have ever found a use for that catalogue – I find that they too easily lead a concept astray through convenience. *The King, from La Ville Abandonée, John Howe © CASTERMAN S.A*

**THE PYKE – PENCIL
ILLUSTRATION**
This sketch was
done standing in a
tower window in the
keep of the castle of
Haut-Koenigsbourg in
the Alsace, during a
documentary shoot.
(It takes camera crews
ages to get set up.)
While I started with a
fairly faithful rendering
of the upper courtyard,
it quickly went astray
into fantasy.

DRAWING MATERIALS: WHAT I USE

For sketching, if your pencil literally engraves the paper, then something is definitely not right. I use mostly 4B and have no trouble erasing – but I don't lean on the pencil until I know the line is there to stay. You can get a very fine point on a 4B pencil if you use a sharp craft knife, and you can dive in with your nose to the paper to do very fine details.

Coloured pencils

I have a few different types of coloured pencils. Derwent make the best selection of an almost disconcertingly wide choice of colours, and Prismacolour manufacture a decent range of softer leads. For finer lines, I have a few harder pencils from the Mongol line by Eberhard Faber.

Sharpening pencils

I cordially dislike pencil sharpeners, which create a mechanical, cold and perfect point. I much prefer a craft knife – the kind with snap-off blades – as it enables you to carve the point of the pencil really long, which will end up corresponding better to the way you sketch. A mechanically produced point is a fixed length and will dictate the angle at which you can hold the pencil, whereas a long, hand-sharpened point will allow you to hold it nearly flat to the page if necessary.

▼ I happily cart my current sketchbook everywhere I go: perhaps half of my sketches are done while waiting for appointments or travelling. Since knives are no longer allowed aboard planes, I sharpen a selection of pencils before boarding flights. I'm always pleased to have the only low-tech laptop in a departure lounge.

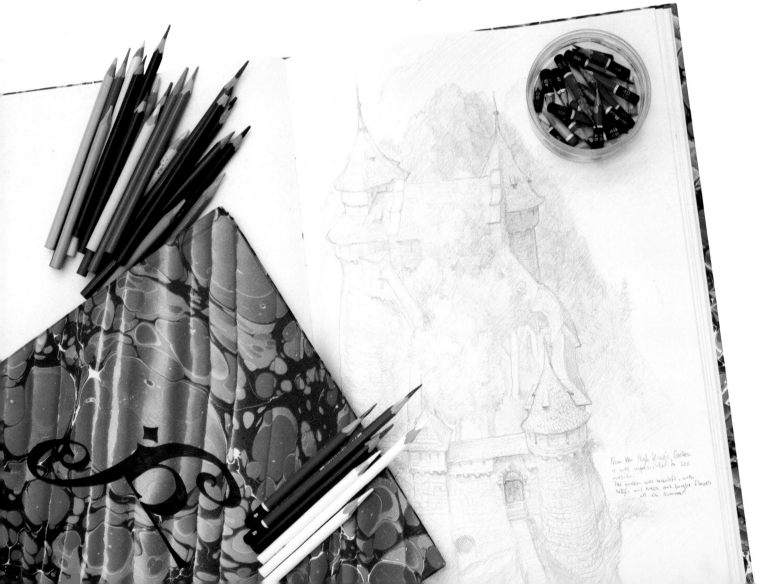

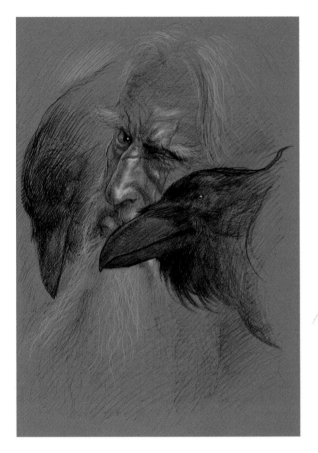

▲ HUGIN AND MUNIN

I cannot remember how this sketch started out. I think I drew the bird, then needed to find the names of Odin's two ravens. I stopped work, found the names, added Odin, added a raven. The farther bird is a little squashed – his beak goes into the gutter in my sketchbook and was awkward to draw. The background tone and highlights were added digitally.

Erasers

Erasers are some of my best friends. I use lovely white ones that are not in danger of colouring the paper. I have erasers of varying hardness and, most useful of all, kneadable erasers, which I cunningly fashion into all manner of marvellous and creative shapes. They leave no eraser scraps, making them perfect for sketching in any situation.

I own an electric eraser. It makes an annoying buzzing sound but is very precise. There is also another kind of soft eraser that 'lives' in a plastic tube, rather like the lead in a mechanical pencil, which is equally handy for erasing small areas.

ANGEL EYES

The angel bowed her head, breathing softly through slightly parted lips. 'Why can't I see her eyes?' thought Erella, 'Why does she not speak, why does she hide her face?' (From *Angel Eyes* by J. Frank-Lynne)
This is the kind of sketch that simply happens on its own, though the feathers did require looking up wing structure in a book on birds. The face belongs to an acquaintance.

35

PAINT AND INK:
WHAT I USE

The following is a fairly comprehensive list of what I use to paint, and how and why. This is not to say the same materials will work for you – each person has different preferences and requirements – but hopefully it will at least fill in the picture.

Brushes and airbrush

Money spent on brushes is well spent. However, you are far better off with one or two expensive brushes than a fistful of cheap ones costing the same amount. The brushes I use range from the house-painting variety (10cm (4in) wide) to fine watercolour brushes (generally No. 6). I enjoy using oil-painting brushes for their stiffness and have a few of those lovely fan-shaped ones, which are wonderful for work on a damp ground.

I own a few airbrushes, which are reserved mostly for those uses where a regular brush will not do the job – adding a tone here and there, darkening a sky or painting armour.

Watercolours

My preferred painting colours are watercolours, available in tubes or pans or cakes. They end up on cheap white porcelain plates, which make inexpensive and durable palettes. The paints, while light-fast and durable, are not indelible, so can be left on the plates to dry and revived with water next time you start work.

Pastels

Dry pastels are often very useful for rendering fogs and smoke. I usually try to leave a light wash for mist, or a darker wash of colour for smoke, but it's not always possible to control the values adequately. On these occasions, a layer of pastel (scraped from the stick into a little pile of dust, then carefully spread out with a soft paper towel) can accomplish just the effect I want. If several layers of pastel are required, it's necessary to fix the picture lightly between layers.

Masking tape and sheets

Personally I tend more and more not to mask surfaces prior to painting objects in the background if I can possibly do otherwise. I've often found my judgment is not sound enough when initially laying a picture out, and I decide to move or change things halfway through. Having reserved an area in white means one is pinned to it, like a butterfly on a board, for better or worse.

The tape you need is definitely the clear matt kind, not the shiny kind. It's the one they label 'invisible', which refers to how hard it is to find when you desperately need it. Do not use repositionable tape, as this does not stick down well enough. To avoid putting down masses of tape, acetate is a useful way of covering large surfaces. Any plastic sheet will do – if you can't get acetate (it can be expensive), in a pinch you can use the clear plastic sleeves sold to hold A4 documents. There is also frisket, which is a sticky thin plastic sheet that comes in different formats, but this is designed for airbrush work, and anything too liquid will probably get underneath.

Place the acetate on your picture. With an indelible felt pen, outline the shape you need to mask, cut it out with scissors and place it on the drawing. It should be no nearer than 10mm (³/₈in) to the edge of the form you wish to mask. Tape all around, trying to have the fewest possible overlaps or junctions. Be creative and think logically how to place the tape – every overlap is a potential disaster area.

When cutting a masking sheet, I can feel when the blade is far enough through the tape to cut it before it touches the paper. It's not that hard, and you need never score

Working on an illustration depicting the death of Beowulf. (And yes, I really am working on it, not just posing with the brush for once.) Oil painting brushes are very useful for water and rocks. In this case I've worked right to the butcher's tape holding the paper on the board, but generally I prefer to keep a frame of white paper masked off around the image.

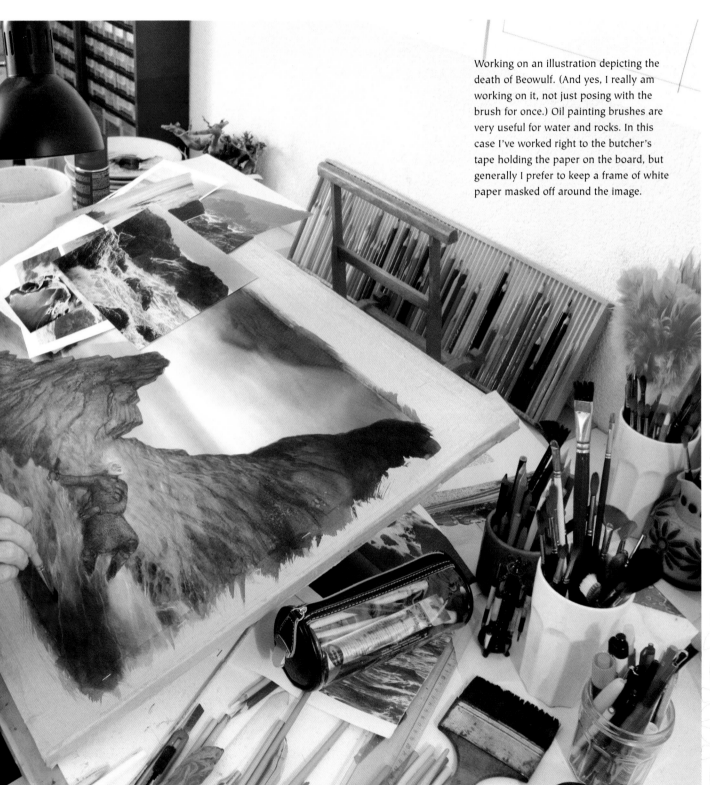

PAINT AND INK:
WHAT I USE

the paper. It is a little more delicate when you have overlapped the tape: often it's best to cut the upper layer first, then the other one, rather than risk marking the paper. Cut out your shape and press down the tape. Pay special attention to overlaps and run your nail along these: the tape must adhere fully and firmly where it rides over the edge of the piece beneath it. Take a deep breath and go for the colour.

The secret and crucial tool you must have at hand is a hair dryer. This will soften the glue on the tape and allow you to lift it off easily, without tearing the paper.

Bear in mind that you must test the paper you use if you have never tried tape on it. Some papers will not take it, and you will be courting disaster. Make sure your paper is dry: even dry to the touch may not be truly dry. To test it, place a small sheet of thinnish tracing paper on the stretched paper; if the tracing paper curls up, your paper is still damp.

Fixatives

Any fixative will do: preferably one that contains no CFCs and is adapted to your medium. Don't use hair spray – it may also contain oils, which are not recommended for artwork, even if split ends may appreciate them.

Paper

Most of the time, I work on an all-purpose, sturdy 250gsm (120lb) paper. This comes in large sheets, and holds up to pretty much all the abuse I occasionally give it. The paper must first be stretched on boards so that it will dry flat. The bathtub in our house is often occupied by paper soaking in preparation for stretching. Warning: stretching paper can be a tedious process, so don't put more than one sheet in the tub at a time. A water-soaked sheet of paper will 'grow' substantially, and when taped down, will dry and stretch like the skin of a drum. When humidified once more (and often repeatedly) during painting, it will always dry flat, even if valleys and ridges form when you wet it thoroughly.

▼ The full range of my brushes – from a 4in house painter's to a No. 5 or 6 sable. The widest are used to wet the full page evenly, and do large areas of colour. The fan-shaped ones are handy for working mid-sized areas on a damp ground, and the watercolour brushes are an all-round tool, and for the finest work. Oil-painting brushes are good for drybrush work.

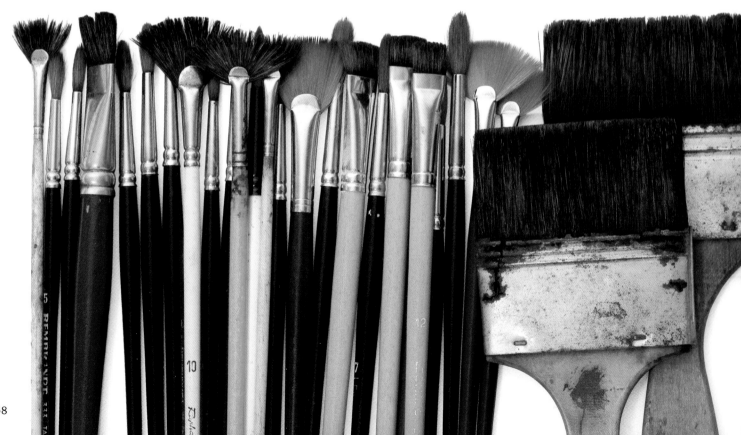

▶ White plates really are the best palettes, far superior to anything designed especially with watercolours and inks in mind. They are cheap, so you can have lots, and you can happily let colours dry and sit until the next time you need them.

▼ A selection of the rest of my tools: airbrushes, toothbrushes, erasers, dip pens, knives, compasses, rulers and various curves. I use the bone folder to the left of the craft knife for transferring drawings from tracing paper to stretched paper. (I rarely use the electric eraser, but go through kneadable erasers at great speed.)

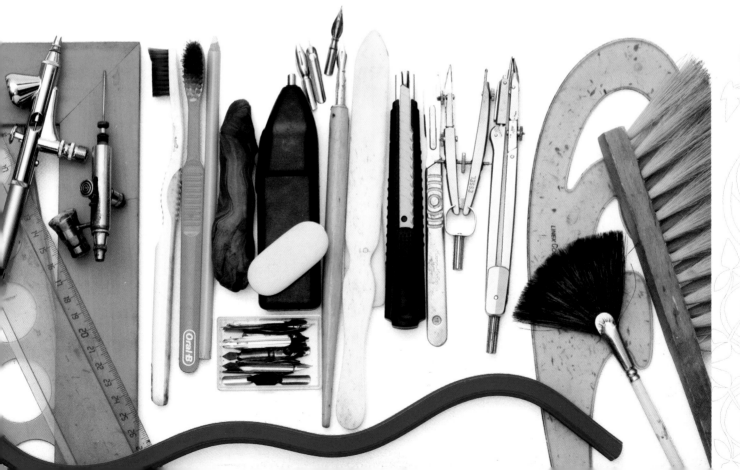

PAINT AND INK: WHAT I USE

Backing boards

The minimum thickness for backing boards should be 1.5cm (½in); anything thinner will eventually warp. The bigger the board, the thicker it needs to be. Buy plywood, the denser the better: marine ply is the best, otherwise any decent ply will do. The wood should not be too tender, and of course it must be smooth. Don't try to save money by getting something thinner or cheaper – the best is not that expensive, and a board will last forever.

A good option is to order boards from the local DIY store that are the size of the paper you habitually use, plus 5cm (2in) or so around the edge. I have several formats, for full, half and quarter sheets.

Illustration board

Using illustration board avoids all the problems of paper, but it takes up more room when it needs to be stored, and it may be stripped by eager photolithographers in order to go through a scanner.

Pens and ink

Some cheap ballpoint pens are wonderful for drawing, and because they're inexpensive, you don't mind losing them so much. Dip pens are very useful for fine line work, especially grass, beards or hair. When you find nibs you like, buy lots of them. They are cheap, and you may have trouble finding more. For colour I use drawing inks, which come in bottles of varying sizes. The inks are not permanent, so, like watercolours, they can be left to dry on the white porcelain plates I use as palettes, to be rediluted next time.

Scratchboard

This is truly excellent for ink work, and you can achieve just about any effect on it. If you are cautious when you scrape and scratch you can even rework the same area several times. Check that your ink is compatible with the board, too.

▼ OLD MAN WILLOW – SKETCH

It's quite unusual for me to do sketches in felt tip, but this one must have been the result of some moment of unusual clarity, as I must have dashed it off in a few minutes. 'Sketches' of this kind are a visual shorthand, done more to remember ideas than as preparatory drawings. They end up being done on anything from supermarket receipts to margins of books to restaurant tablecloths (only the paper ones).

▼ OLD MAN WILLOW – FINISHED ARTWORK

Old Man Willow is actually several willows. Not far from where we live, there is an extraordinary row of pollarded willow trees that I use regularly in my illustrations. I've been diligently taking photos of them for two decades now, and they crop up continually in my work.

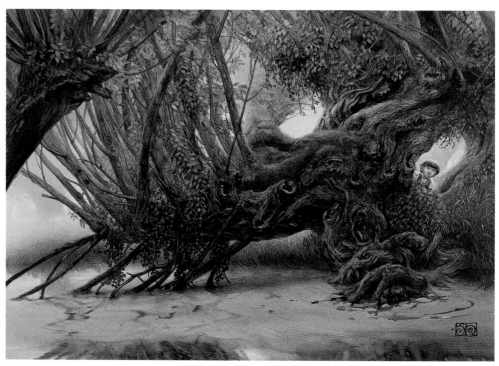

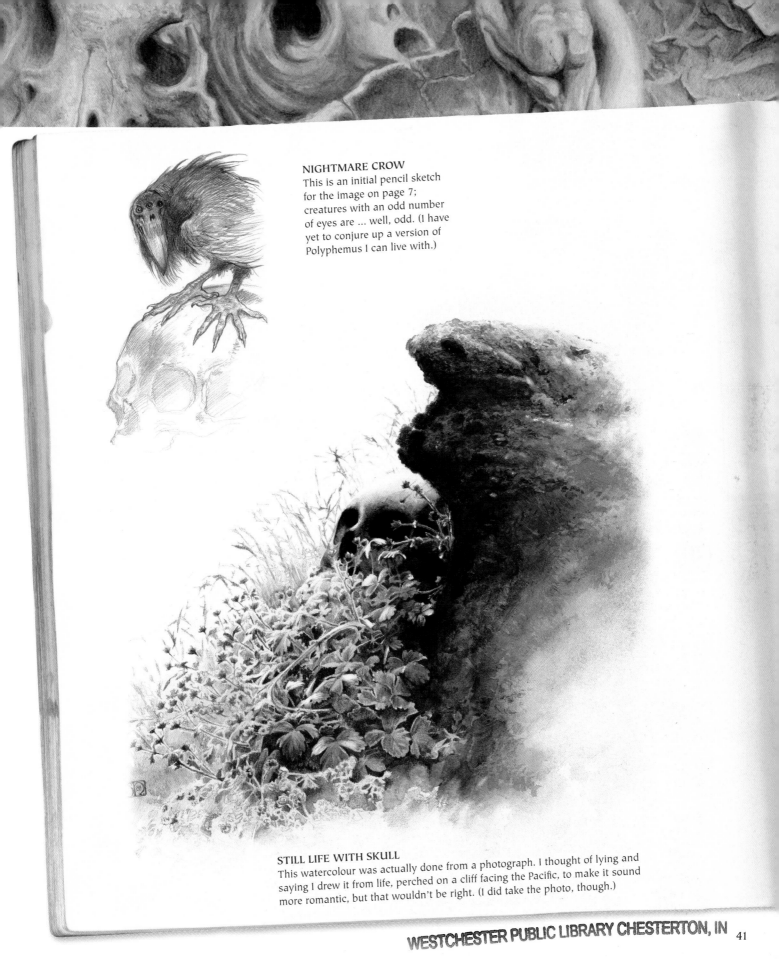

NIGHTMARE CROW
This is an initial pencil sketch for the image on page 7; creatures with an odd number of eyes are ... well, odd. (I have yet to conjure up a version of Polyphemus I can live with.)

STILL LIFE WITH SKULL
This watercolour was actually done from a photograph. I thought of lying and saying I drew it from life, perched on a cliff facing the Pacific, to make it sound more romantic, but that wouldn't be right. (I did take the photo, though.)

OUT AND ABOUT:
DRAWING ON THE RUN

There is no substitute for drawing from life. Generally, unless I am being rained upon or the wind is tearing pages from my sketchbook, I can draw anywhere and at any time, if there is enough light.

Re-examine your art materials: they should be trim and transportable, while not leaving you with a cramped drawing surface, and you should be able to take them anywhere. I have a small knapsack containing a pouch with pencils, erasers and a couple of craft knives, and I use a sketchbook that opens to A3 size, which just fits in the bag – when climbing cliffs or cathedrals, it helps to have both hands free. With a good-size sketchbook you can sit, stand, recline and draw happily in any position wherever you wish – airports, planes, stations, trains, museums or the sofa in your living room – and quickly pack up and move on. The world is your studio.

Carrying a sketchbook means that your doodles are going to be with you for a while, so you can build on themes and subjects. I often get quite a lot of thinking done on long trips, and like to fill up a sketchbook in the summer if I can, since the weather is so conducive to idly sitting out of doors.

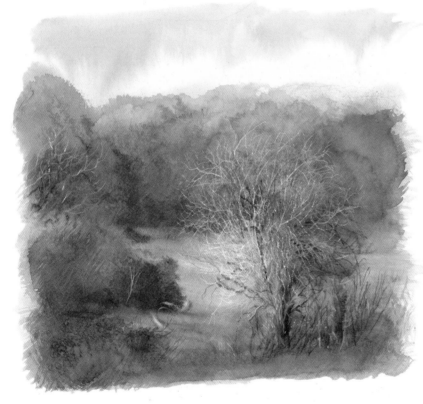

▲ DRAGONS – FIELD SKETCH
The Sunday afternoon painter with his box of paints may be a Victorian cliché, but painting out of doors offers rare moments properly looking at landscape and coming to terms with conditions – shifting light and cloud, depth and perspective.

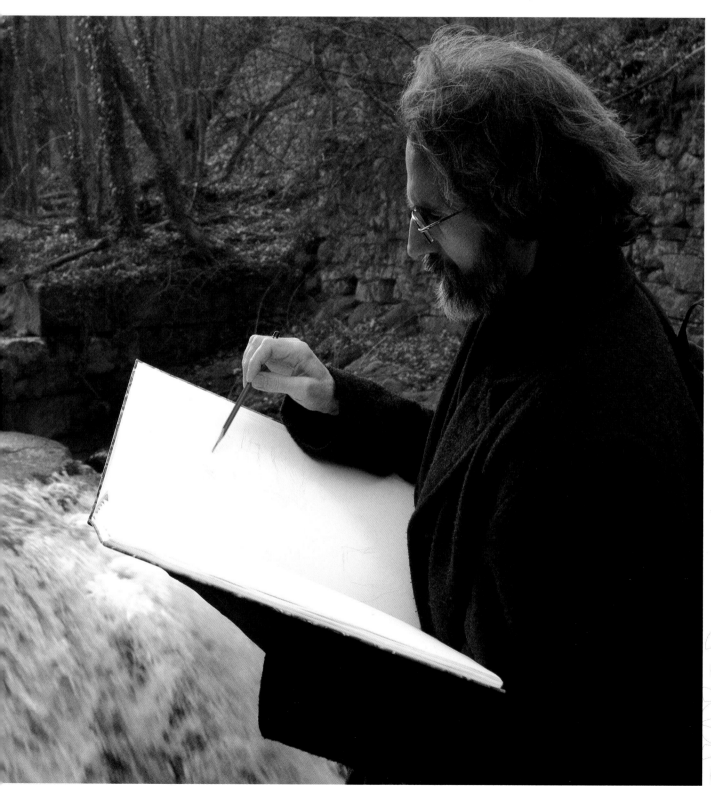

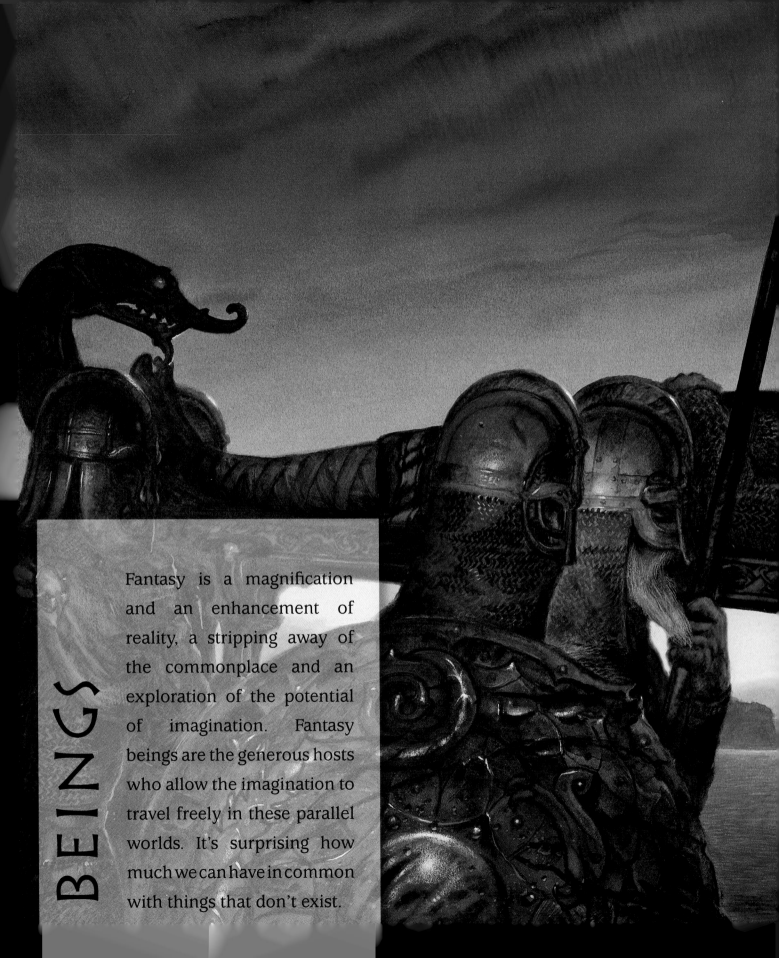

BEINGS

Fantasy is a magnification and an enhancement of reality, a stripping away of the commonplace and an exploration of the potential of imagination. Fantasy beings are the generous hosts who allow the imagination to travel freely in these parallel worlds. It's surprising how much we can have in common with things that don't exist.

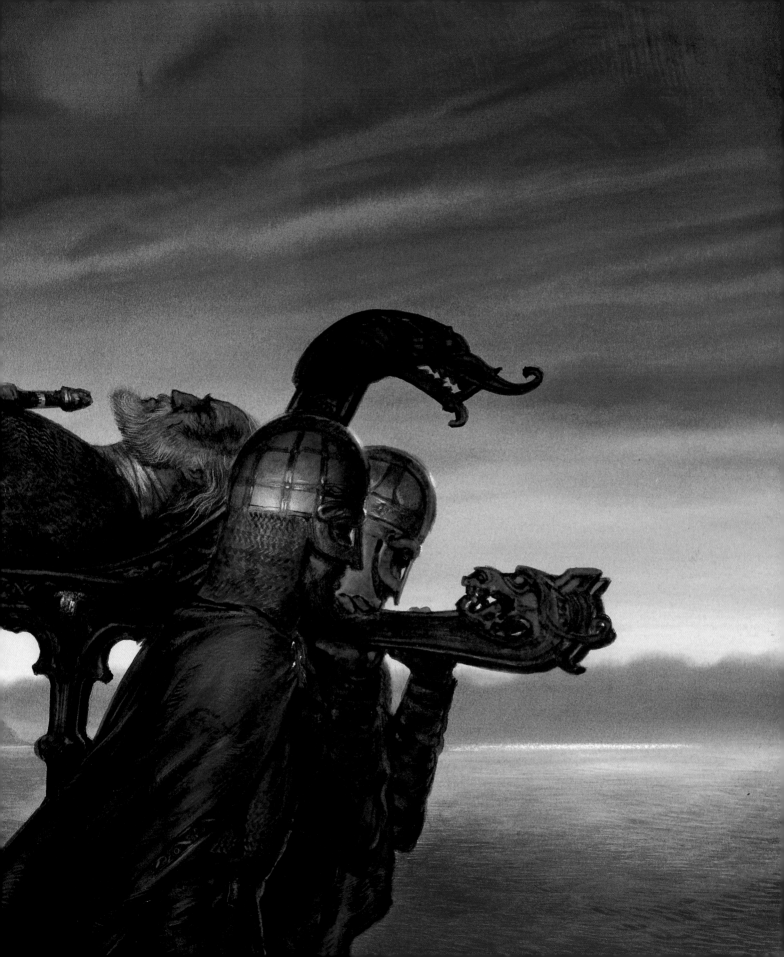

FANTASY BEINGS: APPROACHES AND INSPIRATION

The notion of fantasy beings is of creatures that are composed of elements from thousands of years of human fears and aspirations, that are extensions of our qualities and faults, that are allegories.

There is a fine distinction between fantasy and science fiction, which mythology occasionally strays across. A centaur, mythologically, is a horse's body with a human torso. Period. As soon as one starts asking questions about its bone structure, digestion (omnivore? herbivore? – how *do* they eat enough to keep that huge horse's body going?) or intellect, then it is clearly turning into a speculative proposition for an alien race. The distinction may be a subtle one, and the frontier is certainly not clearly defined, but it will establish the tone of an image and eventually influence its evolution.

ELVES AND DRAGONS
This is the kind of image I most enjoy doing: huge dragons and elves in impossible armour – the full fantasy menu. I spent ages trying to discover a novel shape for the dragons, until I finally stumbled on this silhouette. The passage from the sketch to the colour artwork was quite straightforward. The details are only defined as the colour moves ahead.

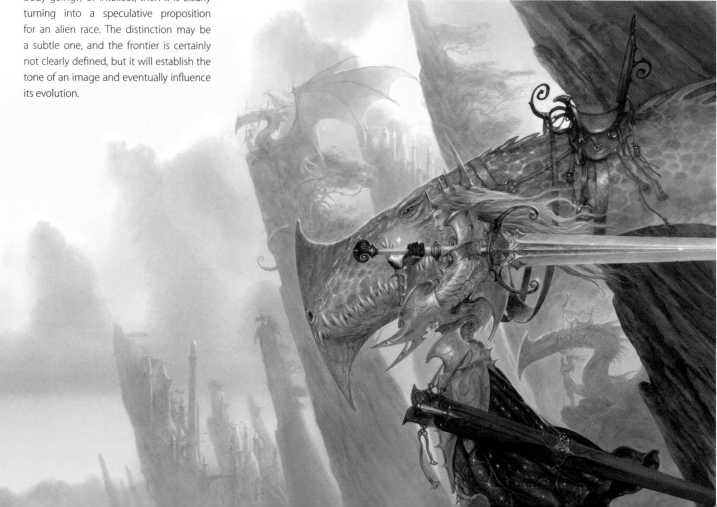

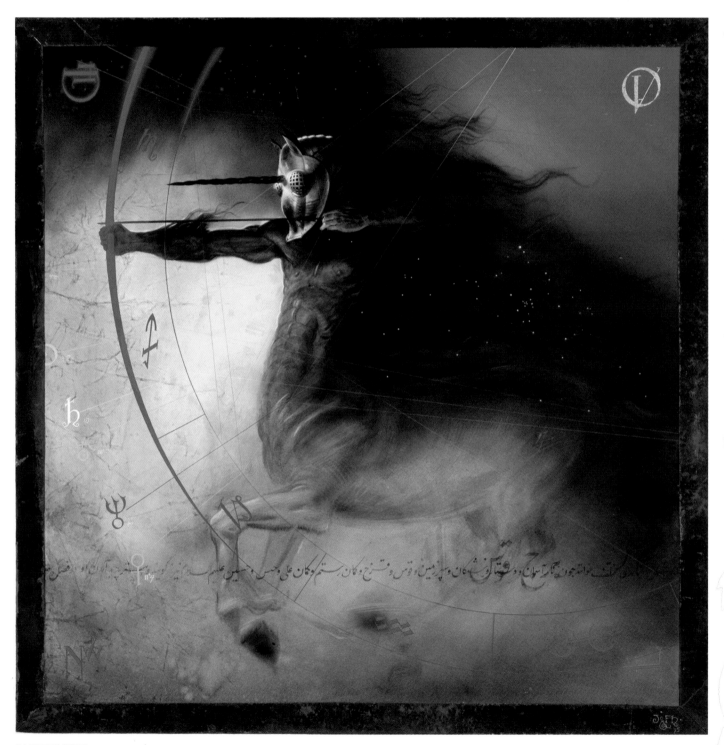

SAGITTARIUS
A painting done for an exhibition on the signs of the zodiac. I ended up posing myself for the torso and the position of the arms. The horse is from a magazine, and the astrological signs and symbols are the sky chart at the time of my son's birth (easy to order from any astrologer).

FANTASY BEINGS: CHARACTERS, SYMBOLISM, ACCOUTREMENTS

History provides a stable terrain on which to build fantasy. In many ways, it is also the stone from which one may quarry the blocks to build one's own universe. History is a deep well from which to draw information. A solid grounding in visual history results in an overflowing of ideas and creativity, especially where fantasy is concerned. (Much of what we 'know' about history is largely fantasy, anyway.)

The ingenuity, creativity and skill of the societies that bequeathed our legacy of myth and legend, evidenced by their surviving artefacts, is astonishing and rich. It is largely illusory to imagine that with a pencil and paintbrush, today's illustrator can capture the beauty of a La Tène spearhead, a Viking sword hilt or a Minoan helm. But a declared and dedicated interest and a certain intimacy with these things naturally leads to the desire to find that same beauty in one's own 'subcreations'.

Tolkien, who coined that neologism, created Middle-Earth from an overflowing of enthusiasm for the words of lost languages. In the same way that his delight in the sound and etymology of those vestiges led to the devising of new tongues for the peoples of Middle-Earth, a modern maker of fantasy imagery can largely ignore the constraints and dictates of archaeology and mine the surviving riches freely.

This isn't in any way a superficial copy-and-paste approach: attentiveness to the essence of visual history comes equipped with the notions of what 'feels right' for any fantasy design. And a little knowledge of the 'real thing' rules out the patently ridiculous, or the terrible tendency to look to Hollywood for authenticity.

But does this really tell us what ogres look like? Does this supply a foolproof method for depicting fairies? Does it tell us for sure that elves have pointed ears?

Of course not. The 'idea' of elves is something we share collectively, but those shared clues do not an elf make. They are a guide rather to what is outside the genre, of what does not 'feel right', as much as they are a list of ingredients. Inside this loose framework is where the artist has all the leeway needed to make a personal contribution to the eternal renewing of the themes.

Nothing is permanent – the rules aren't set in stone in the realm of fantasy. Tolkien's elves are indeed perhaps the best example. From the otherworldly Tuatha de Danaan and the powerful figures of Norse legend to the nursery rhymes and flower fairies of the Victorian era, theirs was an inexorable decline, both in stature and glamour, until an Oxford professor forever changed the way we see them. Elves have never been the same since. For one author to have achieved such a feat single-handedly is unprecedented in modern fantasy literature.

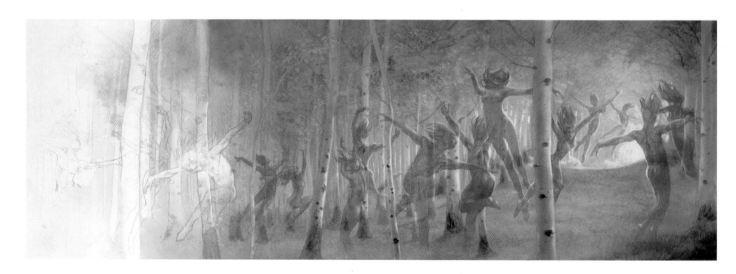

MEMORY AND DREAM
The cover brief stated: 'Crowd of naked red semi-transparent figures dancing in forest setting. Male and female.' In the end, it was not too complicated, although I absolutely emptied the modern dance shelf at the local library. They are pure fantasy, in that they do not rely on any particular reference other than their clearly fantastical nature.

ELF FANTASTIC

The commission sheet basically said: 'Mass-market paperback format on elf/fantasy theme.' Commissions that leave a lot to the imagination are often hard to do, as there is no narrative, only the evocation of a subject.

I have always thought that faërie should be an anthropomorphization of the forest for the purpose of making us heavy-footed and careless humans take more notice of nature.

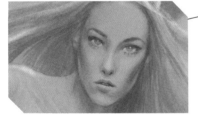

One should be wary of even the most enticing and alluring of elves. They stand on the threshold we cross at our peril, and while the butterfly-winged sprites fluttering around this vision are the fare of nursery rhymes, faërie is a dangerous place.

The highlights on the blackberry leaves were obtained by scraping the surface of the paper with a scalpel. The broader highlights were done with a hard eraser.

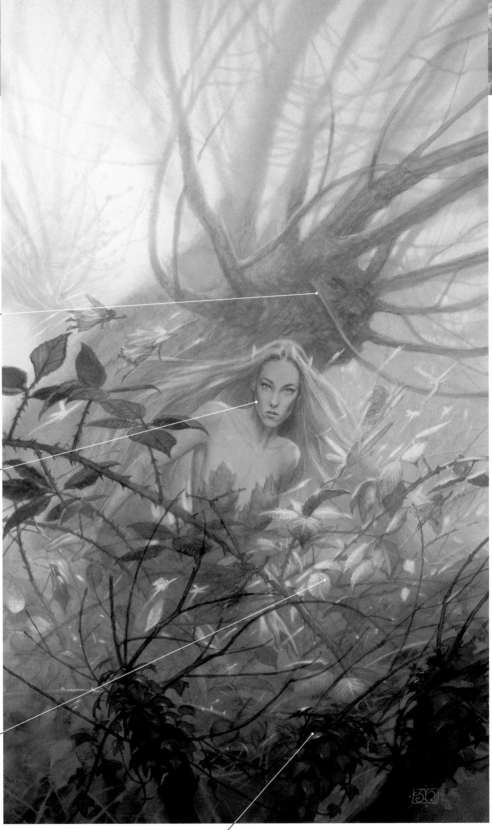

Ivy is a wonderful element to explore – the brilliance of the leaves, the patterns of growth, and its propensity to thrive in the most unlikely places.

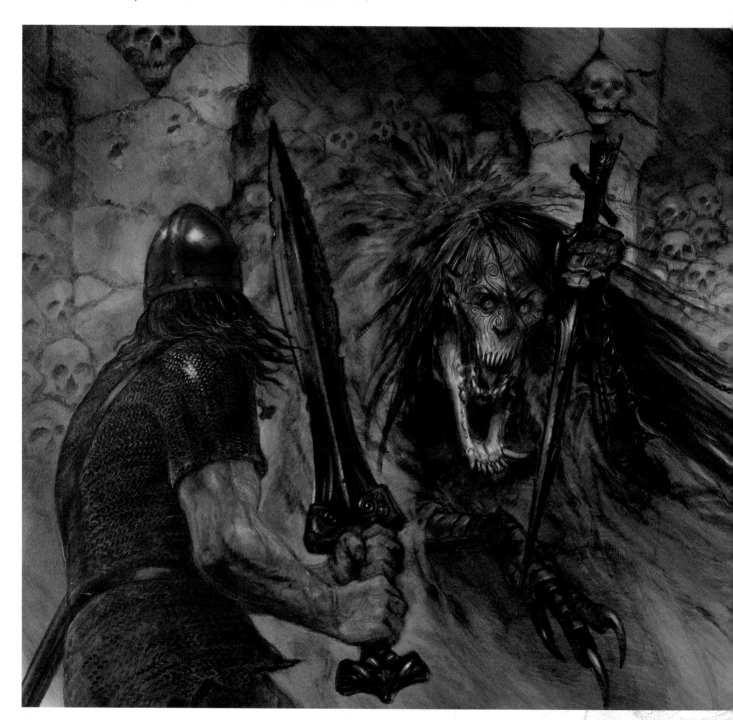

BEOWULF AND GRENDEL'S MOTHER

The monster's heavy tattoos are a vivid memory of the ancient Maori manner of tattooing, which left furrows in the skin, and her scaly, taloned hands are based on a raven's feet. I really think very little about *how* to depict fantasy beings: generally there is some element of them that tells me which way the image needs to go.

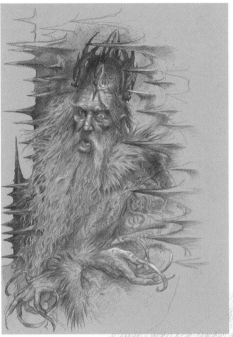

◀ **AERYS II**
This depiction of folly was as uncomfortable to do as it is to look at. Pathologically wary of barbers and their sharp blades, the king refuses to allow his hair or nails to be trimmed, yet is continually scratching and cutting himself on his appalling iron throne.

MERMAID SKETCH
This is the kind of idle doodle that practically draws itself. It began with a Greek profile and eventually ended up with the fins and gills of a sea creature – a mermaid: free sketches usually don't know where they are going until they are done. They often end up going no further, but they are precious notations to remember fleeting ideas and inspirations.

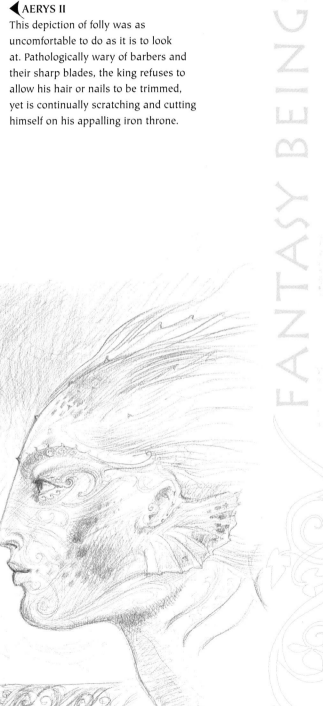

E STUDY: CERNUNNOS

Like any admirer of Celtic myth, I was eager to have a go at depicting Cernunnos, the antlered god. I often sit with one of my many books on the subject and look in awe at reproductions of the Gundestrup Cauldron, on which he appears. I also admit to considerable influence from fantasy author Robert Holdstock's revisitings of traditional Celtic mythos.

FIRST STAGE INITIAL WASHES

This stage is just a matter of breaking the ice, so to speak. I often find it hard to know where to start a picture, so starting all over seems best. Most of this will disappear later, but it serves as a base.

SKETCH

Cernunnos is the great Celtic god of the forest, usually represented with a stag's antlers. My sketch is really a scribble – I spent far more time on the lettering below. Naturally, I went back to look at reconstructions of the prehistoric Irish elk, to get an idea of the absolutely massive antlers it sported, and dug out information on elk skulls. I want Cernunnos to be a hulking figure, dangerous and swift with his huge lance.

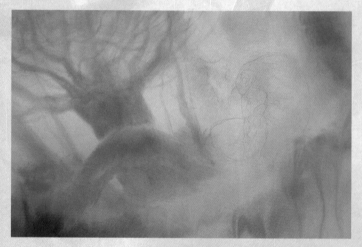

SECOND STAGE RESOLVING THE BACKGROUND

I have decided to put a massive oak in the background, so the whole page gets dampened again to keep the tree from being too present. It can be worked up and detailed later (if enough of it remains visible behind what I've not yet decided to put in front).

FINAL ARTWORK

Well, almost final. I abandoned the elaborate knotwork border I had originally planned, though I may do it later when I have a moment to spend on it. Adding the vertical raindrops and the relentless drip-drip-dripping of the rain-soaked forest was really well worth waiting for until the very end of the painting. The intense colours in the foreground heighten the sense of dampness. White pencil crayon came to the rescue to add the cold light in the far background, and those two tiny spots of white behind the creature have defined his silhouette and brought him out of the roots he was entangled in.

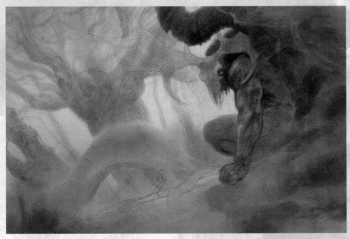

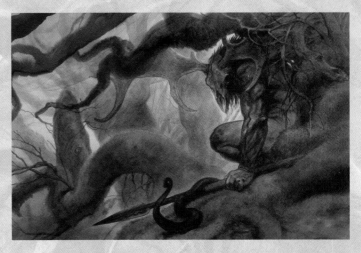

THIRD STAGE BLOCKING IN THE FOREGROUND

Starting on Cernunnos himself, and blocking in the roots and trunks in the foreground. I have decided to add a snake coiling around the lance, as serpents are apparently the god's familiars. His body is painted with a wide brush, building up the muscle masses. I've used my own arm as a model (though it's much thinner than that, of course) – it's difficult to find decent photographs of muscular bodies that are not body-built out of all semblance to reality.

FOURTH STAGE WORKING UP DETAIL

Working up roots and branches. I've suddenly decided to add a standing stone, painted with a wide brush and a quick (and indelible) stroke of colour. The right antler is blocked out, waiting until I decide what will go in front of it. At this stage, nothing looks any good: his skin is dull, the area behind his head is confused, the branches aren't working. His skull mask has been reworked but is still not quite right. This often happens in the middle of a picture, but there's no choice but to carry on and hope for the best.

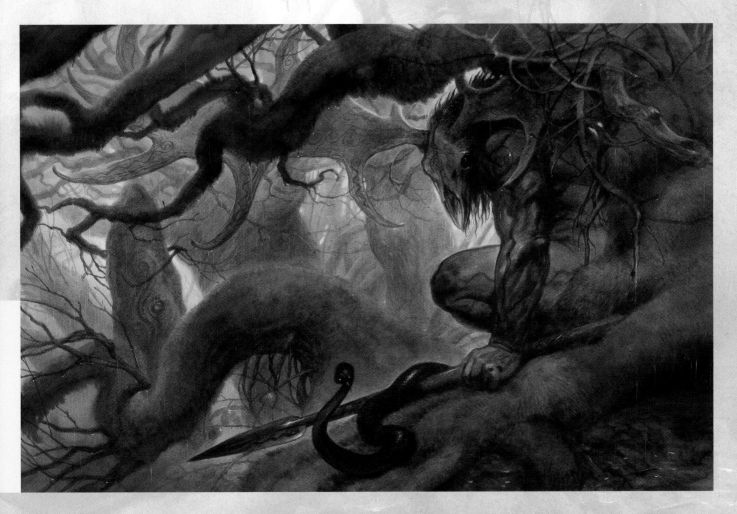

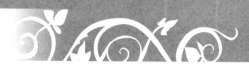

HUMAN BEINGS: MALE AND FEMALE ARCHETYPES

Archetype: 'Mid-16th century: via Latin from Greek *arkhetupon* "something moulded first as a model" from *arkhe* "primitive" and *tupos* "a model". In Jungian psychology, it is a primitive mental image inherited from our earliest ancestors and present in the collective unconscious.

I don't think anyone has ever seen an archetype, but it's a concept that emerges constantly in fantasy art, in the depiction of the heroes of myth and legend. At any rate, it is a sort of grail to be sought diligently. Only in the pursuit of archetypes can we gain any conviction as to their appearance and understanding of how we create them in our subconscious, and in turn depict them.

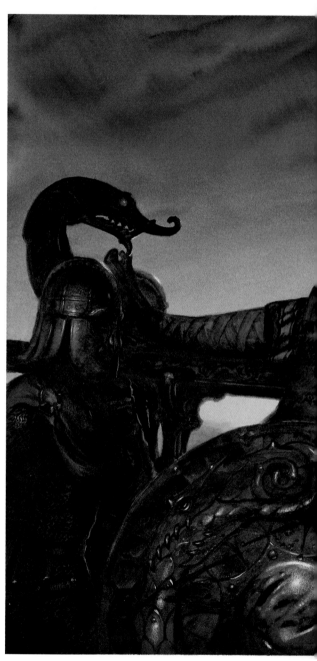

◀ MELUSINE

The lovely, tragic tale of Mélusine, who secretly acquires a serpent's tail each Saturday, is typical of the intertwining of ancient legend and medieval romance. Originally a mermaid-like water spirit (as she appears in the framing image), she is an archetype of feminine allure. Exploring the female figure was a welcome relief after drawing acres of dragon scales.

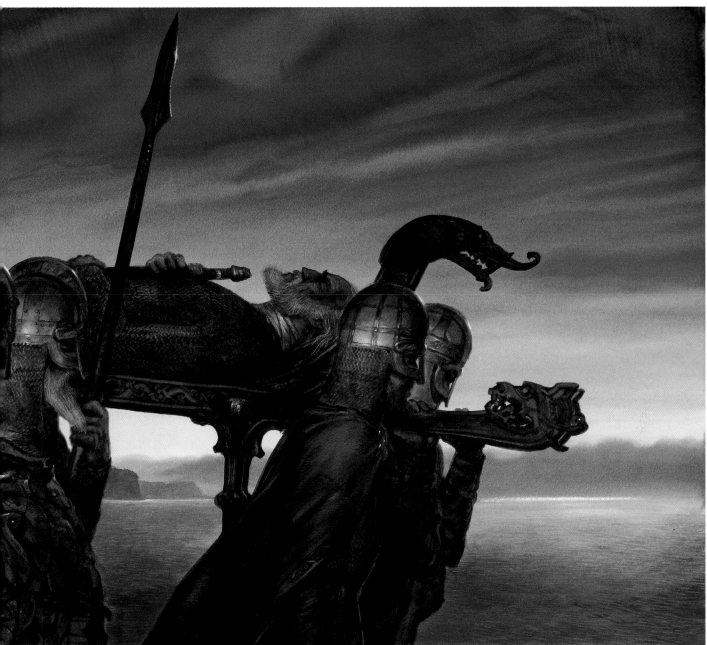

BEOWULF'S FUNERAL

Everything we recognize is composed of two things: the idea, or essence, of it and the details of its physical presence, and both are ideally present in a fantasy illustration. Nowhere are the two elements more clearly balanced than in the archetype. Beowulf is neither an abstraction nor a historical figure, but represents an aspect of humanity. This image is a mix of the thoroughly researched – the helmets and

costume – and the completely made-up, though I did spend time staring at Viking furniture, imagining how a seventh-century carpenter might have constructed the bier. The mythological Viking funeral, with thewy thanes straining to push a flaming longship out to sea, while potentially a stirring image, no longer really holds water. In the end, the slight inclination of the bier and the low horizon suggest a solemn procession down to the shore. The rest is left to the imagination.

HUMAN BEINGS: ACTION

Movement is part of our make-up, it is inherent in every living thing and in everything we do. Nothing is ever really still in nature, any more than time can stand still, and we have to reflect that in the drawings and paintings we make.

There are many ways to treat action. Photography has given us the ability to seize movements invisible to the eye, slowing and freezing them as we wish. More powerful than the action itself, however, is the split second that precedes it – the indrawing of breath or tensing of muscle that can contain the potential of the action.

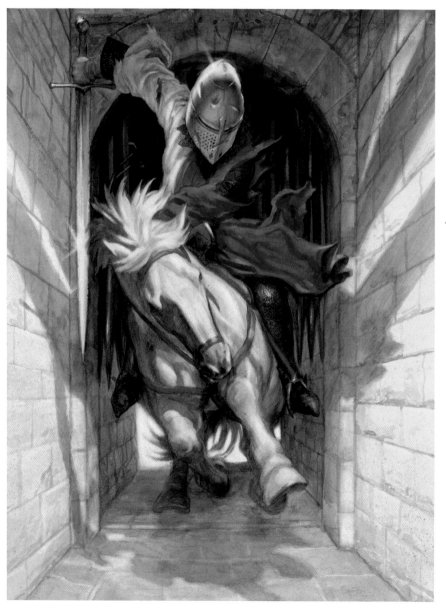

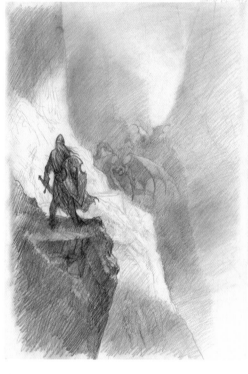

▲**THE FLIGHT FROM GONDOLIN**
An image like this is really about what is about to happen. The action is contained and suspended in the narrative: while the protagonists are immobile, the confrontation is drawing inexorably nearer.

YVAIN'S ESCAPE
In the original story by Chrétien de Troyes, Yvain's horse is cut in two. That was judged a little grisly for children's fare, so here the falling spikes just clip the heels. Rather than attempt to achieve split-second freeze frames in fantasy illustration, it is often more eloquent to convey the spirit of the movement more naturalistically, by leaving some things blurred by speed. I often find myself blurring hard edges, or blocking in forms with a wide brush and stopping short of providing more detail than the subject requires. Everything here is exaggerated, from the horse's pose to the impossibly long sword Yvain somehow manages to wield while galloping madly down a narrow passage.

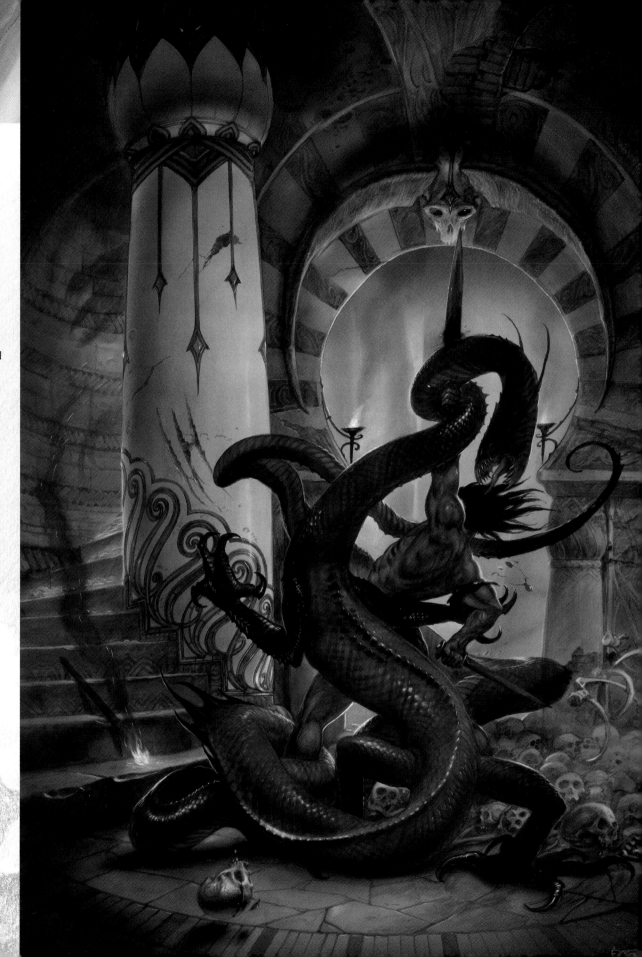

RED NAILS

Red Nails must be one
of Robert E. Howard's
best Conan stories. The
Cimmerian finds himself
caught between two
warring tribes locked
away in a labyrinthine
city. This is a stop-
action image, everything
poised in mid-air, in
mid-gesture. 'Freezing'
movement is not a natural
process: movement can
be arrested through an
understanding of motion
and anatomy, though not
with the clarity provided
by photography or slow-
motion film sequences.
Every detail added will
'slow' movement.

HUMAN BEINGS: ARMOUR AND WEAPONS

With armour, it's very simple: metal plate doesn't have much stretch, so it will either work or it won't. A working knowledge of different styles and periods will greatly help in developing your own fantasy armour.

Armour doesn't stay on by magic. Straps, buckles and leather thongs hold it in place, so don't forget about them when you are blacksmithing in pencil. (Late medieval jousting helms had a system of padding and straps inside them as sophisticated as a modern American football helmet.) Armour was worn over a sturdy garment, both to serve as a foundation and to protect the body, not only from concussion but from the armour itself.

Weapons are nasty sharp pointed things destined for one purpose only, but they contain a slim elegance and power that is forged in the metal itself. The lumpy, clumsy heave-aloft-and-bash swords of yore never really existed. Weight and balance are of the essence, but fantasy allows great liberties and a layman's familiarity with real medieval weaponry will confer a believability on your extrapolations.

The rondel on the lance is taken from a book on jousting. The huge funnel-shaped guards are typical.

CENTAUR ARMOUR

This painting from the early 1980s is one of several in the style of 19th-century treatises on the art of war, which were in turn produced in imitation of Renaissance works. Horse armour reached extravagant proportions in the early Renaissance, sometimes encasing the whole animal.

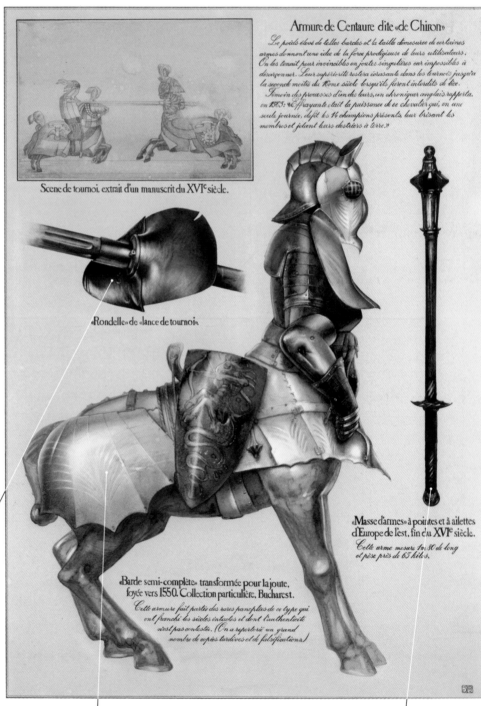

Armure de Centaure dite «de Chiron»

Le poids élevé de telles bardes et la taille démesurée de certaines armes donnent une idée de la force prodigieuse de leurs utilisateurs. On les tenait pour invincibles en joutes singulières car impossibles à désarçonner. Leur supériorité restera écrasante dans les tournois jusqu'à la seconde moitié du 16ème siècle lorsqu'ils furent interdits de lice.

Témoin des prouesses d'un de leurs, un chroniqueur anglais rapporta en 1583: «Effrayante était la puissance de ce chevalier qui, en une seule journée, défit les 14 champions présents, leur brisant les membres et jetant leurs destriers à terre.»

Scène de tournoi, extrait d'un manuscrit du XVIe siècle.

«Rondelle» de «lance de tournoi».

«Masse d'armes» à pointes et à ailettes d'Europe de l'est, fin du XVIe siècle.

Cette arme mesure 1m 30 de long et pèse près de 65 kilos.

«Barde semi-complète» transformée pour la joute, foyée vers 1550. Collection particulière, Bucharest.

Cette armure fait partie des rares panoplies de ce type qui ont franchi les siècles intactes et dont l'authenticité n'est pas contestée. (On a répertorié un grand nombre de copies tardives et de falsifications.)

The hard edges of the metal and the 'segmented' nature of armour mean that it lends itself well to repeated masking.

Real war-hammers, axes and maces are surprisingly small – unlike film props. This one is exaggerated to fit the equine strength of the centaur.

▼ RHINO ARMOUR

I imagined these creatures in a fantastical sort of Thirty Years War Europe, carrying huge bronze muzzle-loading cannon, seconded by an artillery crew with powder and shot. Paintings often open up unexpectedly on worlds of their own. The gauntlet's clawed thumb was inspired by a raven's foot.

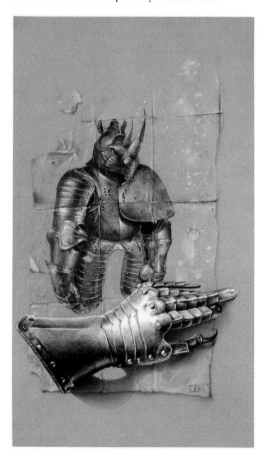

LANCELOT

Polished steel has a mirror-like surface, so an airbrush is often indispensable to obtain smooth curves, though in fact there is no airbrush work in this painting. Contrasts can be strikingly sharp, and mastering the highlights is as crucial as getting the shapes right. Like a mirror, armour will reflect a good deal of the atmosphere surrounding it. The armour itself is in the Paris Army Museum.

HUMAN BEINGS: FACES, EXPRESSIONS, HANDS

Faces and hands are understandably among the hardest things to draw well, as they are the features we know the most intimately.

Mervyn Peake, author of the *Gormenghast* trilogy and a renowned illustrator, wrote in *The Craft of the Lead Pencil*: 'The beginner doesn't think in terms of "heads". He thinks of "faces".' It's easy to forget that the features are anchored to the head, and to think in terms of detail rather than volume. One of the better ways to capture a face is to begin from the inside, finding the foundations on which the features rest before losing yourself in an accumulation of detail.

Heads and hands abound. Your friends may initially be reluctant to pose, and you may be reluctant to show them your efforts, but persist. It can help if you are not consciously drawing the person, but using them as a model for another character, liberating you from the task of producing a 'faithful' likeness.

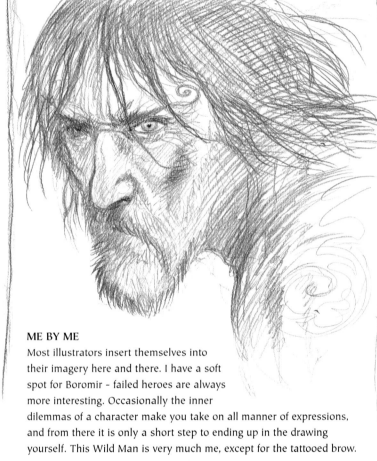

ME BY ME
Most illustrators insert themselves into their imagery here and there. I have a soft spot for Boromir - failed heroes are always more interesting. Occasionally the inner dilemmas of a character make you take on all manner of expressions, and from there it is only a short step to ending up in the drawing yourself. This Wild Man is very much me, except for the tattooed brow.

KING AND CROW ▶
The profile of the King is taken straight from a statue that was once on Strasbourg Cathedral (and has now been replaced by a reproduction). Medieval faces are often disconcerting to modern eyes, but they contain an inherant elegance that it is worthwhile trying to understand and capture.

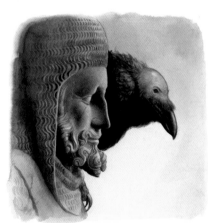

PILLARS OF HEOROT
This is a sketch for a film project based on the tale of Beowulf. Attempting to emulate sculpture from another period and culture is a revealing exercise. It is very hard to keep modern realism from intruding, and to keep sophistication at bay. The face and figure on the Viking post have been reduced to simple forms.

THE GLASS PRINCESS

Illustration from *The Abandoned City* by Claude Clément. The two characters are drawn from rather different models – the glassblower is my wife's father and the princess is based on the 15th-century painter Hans Memling's 'Reliquary of Saint Ursula' in Bruges. *The Statue*, from *La Ville Abandonée*, John Howe © CASTERMAN S.A

There is a manner of concentrating that widens the eyes and wrinkles the forehead rather than narrowing them and knitting the brows. This indicates application to the subject without attempting to dominate it.

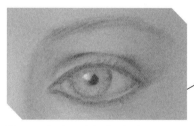

The eyes in the original painting are downcast, but it was important to have them looking out of the picture with the ambiguous, unfocused gaze of a statue coming to life.

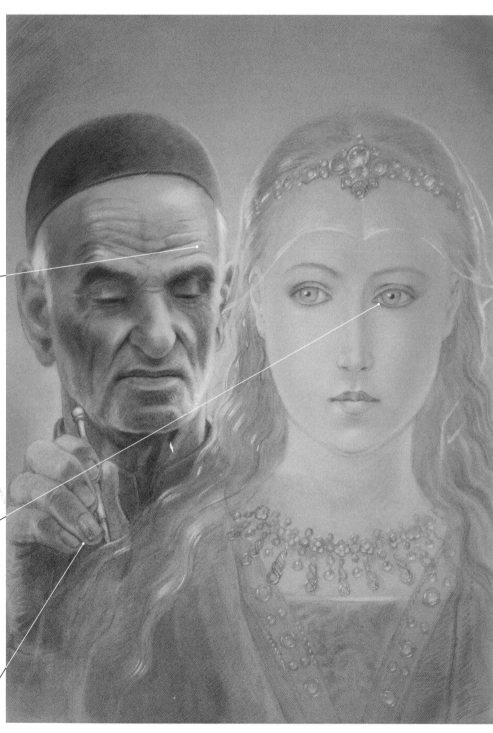

This is my hand, drawn by looking in a mirror. Hands are better achieved by thinking first in terms of volume before tracing careful contours.

HUMAN BEINGS: HAIR AND COSTUME

lothes may not make the man, but for fantasy beings, they certainly help. Convincing costume is fundamental to well-dressed mythological individuals, or they will not be perceived as 'real'.

Once again, there is no substitute for the real thing. Spend time in museums. Take home catalogues. Learn to appreciate period images. Take photos if you are allowed, but try to sketch on the spot: photos may not clearly show how costume actually works, but sketching, even quickly, will help you remember when it comes to using it in a picture.

Hair is obviously impossible to paint, all one can do is suggest it, getting the brightness in the right place and making sure that the volumes and state of the hair (wind-blown, in motion, wet, dry) are captured. The viewers' imagination will do the rest.

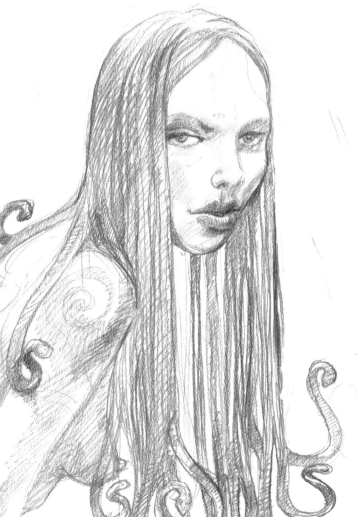

◄ MEDUSA
There is something quite disquieting about a snake held by the tip of the tail; even when hanging limply, the head is always level, and the snake ready to tense. That seemed more hairlike and more apt for this seductive Medusa than a halo of writhing serpents.

▲ THE LIMBRETH GATE
Sketch for a book cover. It was important to convey the heroine's tight-lipped determination and readiness to step into the unknown through the Limbreth Gate. The billowing dress and hair add to the tension, as if there was a difference of pressure between her world and the one beyond the wall, making the passage more than just taking a few simple steps.

LANCELOT

The armour is done from a photograph. (That's me inside – I am skinny enough to fit into most armour, which is very handy.) Do beware of suits of armour displayed in museums: unless they are strapped to a life-size, properly proportioned figure, they may be sitting all wrong and be misleading. Modern reproductions rarely get the proportions right, so also beware of photos of re-enactors unless their costume is impeccable. This armour, a 19th-century copy of a 15th-century harness, belongs to a friend.

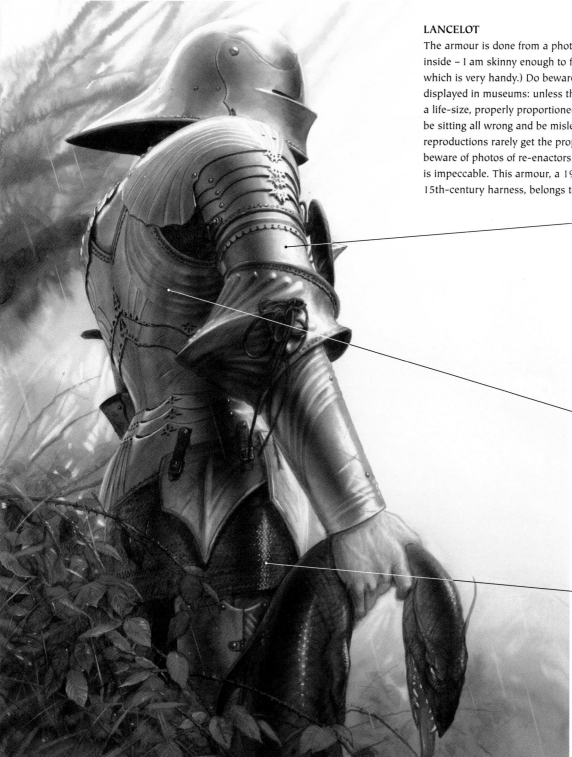

Only orcs and down-at-heel bandits wear rusty metal. Soldiers spent much of their time cleaning their armour. Polished steel can be like a mirror, so rendering it means mastering sometimes startling reflections.

There is no standard method for painting metal; its aspect varies with the light and location. The volumes of armour are done with an airbrush, and highlights with a scalpel and hard eraser.

Rendering chain mail can be irksome: alternating lines of closely packed 'c' strokes is one method. Adding a few highlights at the end also helps. Remember it is not cloth – it hangs heavily, so the weight should be apparent.

Occasionally I'm lucky enough to have a real person and a character in a book coincide. The real Tom Badgerlock was a strongman in a travelling street circus in the South of France. When he had finished breathing fire, breaking chains and rolling on broken glass, I asked if I could take some photos. Several years later, when illustrating covers for Robin Hobb, everything fell into place: I had my Tom Badgerlock.

FIRST STAGE GROUND-WORK

A picture that consists of such independent elements has really no logical step-by-step methodology. When working with detailed figures, I prefer to reverse the order and work from front to back, rather than masking off an element before I'm really sure where it will go. Many of the elements shifted place several times.

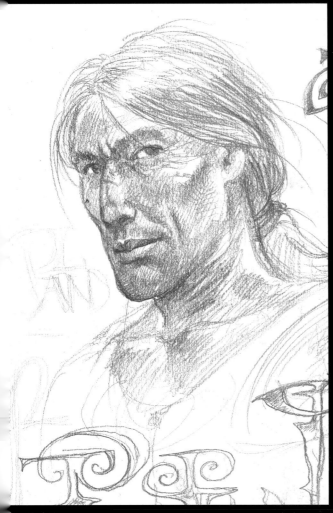

SKETCH

The first sketch dates from several years ago, when I did the cover of Robin Hobb's *The Golden Fool*. A page full of doodles ended up with a sketch of Fitz in it (see page 108). For the rest of the figure, I asked a friend to come around and pose: I did thumbnail sketches and took photos. The arming doublet is his, the rest of the gear is mine.

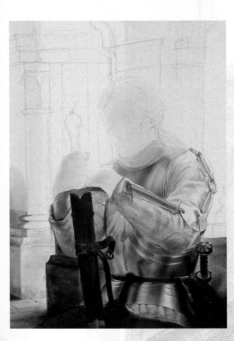

SECOND STAGE FOREGROUND FIRST

This step may not actually be a logical one – it could have come a little earlier or a while later. I did want the picture to be contrasted, hence the early blocking in of the shadows. At this point, much is still undecided, especially in the background. A painting at this point is very unsatisfying, and it can be hard to maintain a view of the whole and not to let the paint-by-number reflexes take over. This means doing quite a lot of work on reflected light, filling cold shadows with warm sidelights and generally trying to sculpt and situate the volumes within the space of the image.

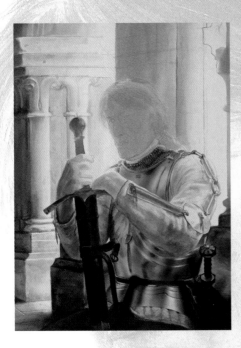

THIRD STAGE WORKING BACKWARDS

The background has more or less resolved itself, but the face is actually pretty awful. Sketching in faces with pencil is something I rarely manage convincingly (as my wife, bless her, didn't hesitate to point out in passing, in that nice way she has). The picture is even more unsatisfying at this point, since the mix of near-finished elements throws attention on the blank spots. Actually, the whole slightly haphazard approach I have adopted is simply to defer making decisions as long as possible. The haphazard defining of detail after detail slowly builds the atmosphere and the place (the castle of Buckkeep, in this case, the site of much of the action in the novels), which in turn makes the 'encounter' with Fitz possible. This sounds precious and esoteric, but it really is like stalking wildlife. Saving the face until last means that by the time I arrive at that point, I know what expression and features are required to convey my thoughts on the character. (This is, admittedly, what happens in an ideal world – not only is it not possible with every commission, but one can also easily miss the mark.)

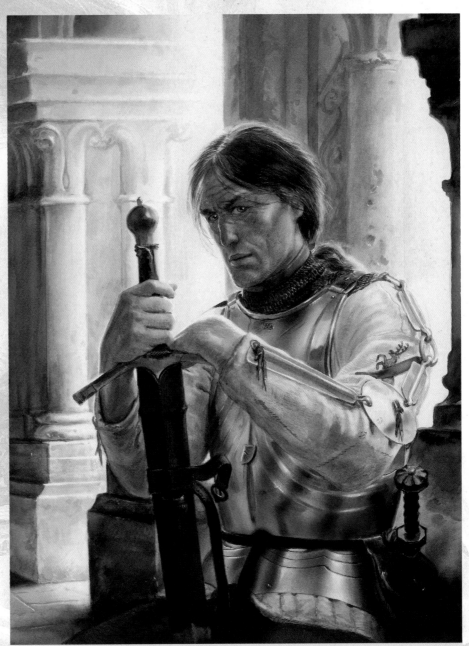

FINAL ARTWORK

FitzChivalry, or Tom Badgerlock as he is called later in the novels, is an ambiguous and reluctant hero, a puppet of causes and powers beyond and above (and within) him. Here, he is perhaps in his late thirties or early forties, still unafraid to fight and confident in his skills, but possibly pondering on the wisdom of it all. His gear is well worn – missing point ends, scabbard broken and repaired with the knife and file gone, breastplate polished but marked, sword with worn grip and matt pommel, with the crossguard broken and re-forged – all the little signs of trustworthy but well-used equipment. His face has a few scars, and as for his expression, well, I tried my best to catch my own mixed feelings about his place in the novels: something of resignation without submission, of loss without defeat, of strength and doubt. I would happily do a series of portraits of him, from youth to old age. It is unusual to find such complexity and depth in a fictional character. (And next time I'll get the colour of his eyes right – Robin Hobb tells me they are dark, not blue.)

FANTASY BEASTS: APPROACHES AND INSPIRATION

I often wonder about what we call 'collective consciousness' in relationship to beings that do not exist outside the realms of imagination. Throughout time, it seems, humans have filled the spaces they cannot explore with creatures drawn from their fears and hopes.

But myth-history is only a point of departure, and the only limits are those of the imagination. I'd be tempted to say, for example, 'Unicorns are often described as slim horses, with cloven hooves and a horn in the middle of their foreheads.' I would never state: 'To draw a unicorn, start with …' Formulae should be banished from fantasy. While there is often a governing idea, there are no rules and no fixed borders. Giants don't necessarily have low brows and snaggle teeth, even if some perhaps do. A regrettable tendency towards inherited stereotypes that capture none of the incredible diversity of fantasy creatures can easily transform them into a resumé of typology rather than individuals.

I often find my pencil stopping in mid-stroke, and wonder just why I am drawing something the way I am. Often the pencil is obeying convention and habit rather than innovation and originality. That is a good time to get out the fantasy eraser and begin anew.

 SEAHORSE SKETCH
A summer sketchbook doodle. I do my best to do one sketch per day whenever we are away. Usually there is a moment of idleness that can be turned into a few lines. If centaurs exist, then why not sea-centaurs?

THE WANDERING FIRE
This is by far my favourite cover of Guy Gavriel Kay's Fionavar trilogy. I keep a collection of photos of large marine mammals for the manner in which they break the surface of the water, and another drawer full of photos of snakes for scales. A snake's body is never simply round, like a sausage, it is a sinuous continuum of intersecting lines of force. A few highlights on scales help make the creature come alive.

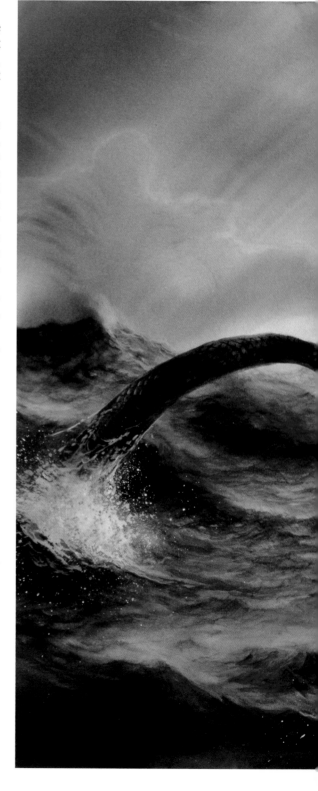

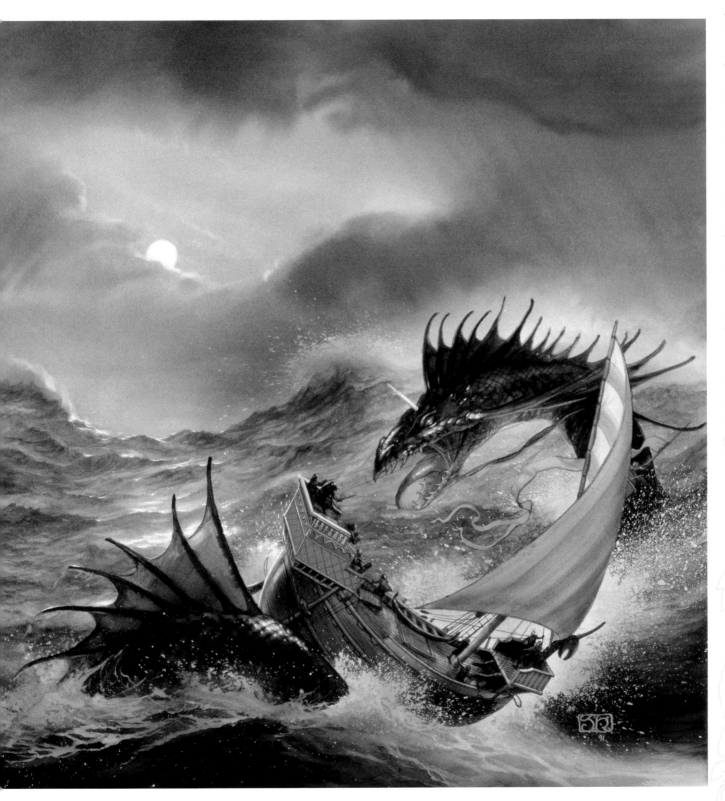

FANTASY BEASTS: TALONS, WINGS, FANGS AND FIRE

F antasy creatures often have family trees stretching back beyond history. Like gods and heroes, their hoary, scaled and fanged foes have pedigrees spanning the world. While the concepts themselves are often universal, their applications are myriad. Many live exclusively in folklore, often under one particular bridge, or in a certain tree; others go by a hundred names in as many places and times.

Today's illustrators can be the worthy successors of the medieval illuminators, who crammed their manuscript margins and lettrines with vouivres, sciapods, blemmyae and cynocephali. The genesis of fantasy beasts has often followed a complicated path. Bestiaries were one of the grand inventions of the Middle Ages, when the world was potentially peopled with all manner of fantastical creatures. Many of the archetypal beasts that haunt the edges

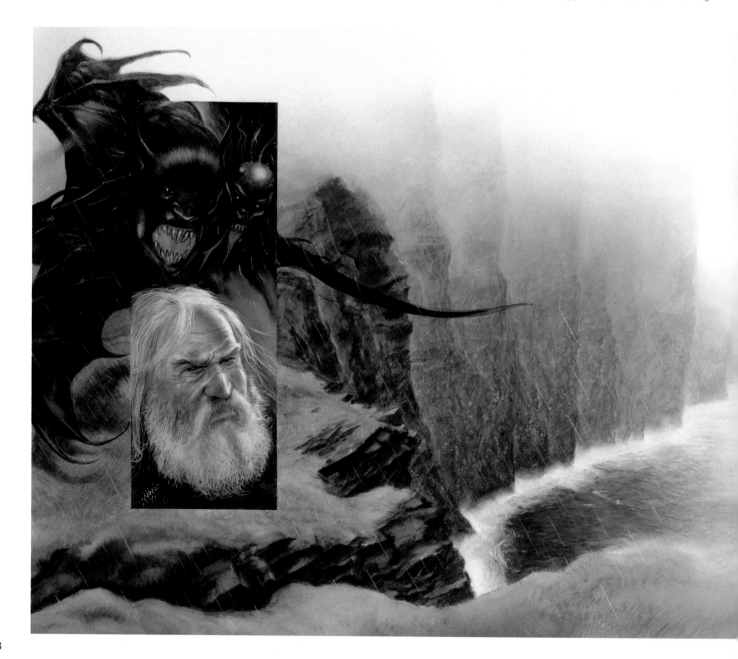

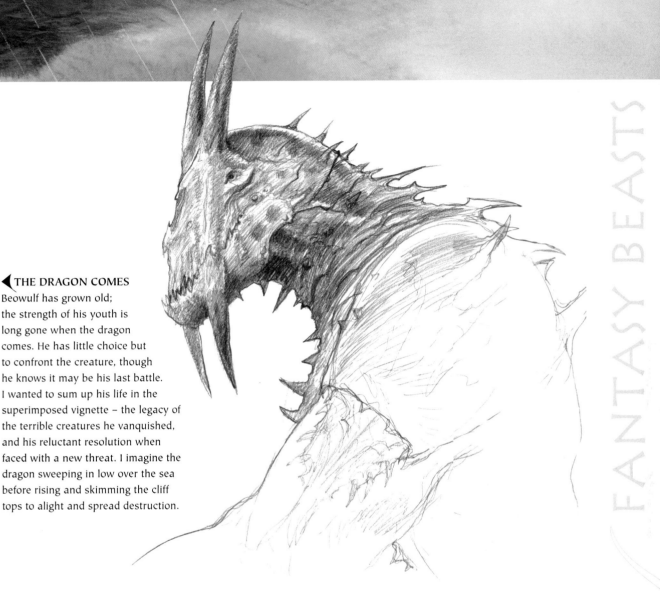

◄ THE DRAGON COMES

Beowulf has grown old; the strength of his youth is long gone when the dragon comes. He has little choice but to confront the creature, though he knows it may be his last battle. I wanted to sum up his life in the superimposed vignette – the legacy of the terrible creatures he vanquished, and his reluctant resolution when faced with a new threat. I imagine the dragon sweeping in low over the sea before rising and skimming the cliff tops to alight and spread destruction.

of the world appeared there in numbers – unicorns, manticores, amphisbaenae, salamanders, ant-lions and others – and have continued to be depicted by artists over the centuries.

Modern fantasy has conscientiously revisited these archetypes, transforming, extrapolating, rationalizing (applying 'scientific' reasoning to fantasy) and grandly expanding the genre. Their fantastical nature, which need not obey even the most elementary laws of biology, allows for a certain cut-and-paste freedom that is a welcome respite from the chore of bestowing 'convincibility' on fantasy. Hairy, scaly, clawed and feathered, the palette of textures they demand is enough to make you want to turn to the nearest natural history museum and spend an afternoon. They are the perfect excuse to look at real animals properly and build up your portfolio of references. For example, the apparent weightlessness of flying creatures means a lot of pushing heartily and repeatedly downwards. Wings are exquisite creations of nature, and careful attention to their structure and size in the real world will lend credibility to an illustration.

QUAY SKETCH

The Quay are a race of aliens designed for a card game. When my son was small, he delighted in wearing both his Batman masks at once, one as you'd expect, the second upside down, which transformed the ears into fangs. Now there is an interesting idea, I thought at the time. A decade later, the idea generated the Quay design process.

'Quay' © Decipher Inc.

FANTASY BEASTS: TALONS, WINGS, FANGS AND FIRE

The bone structure of a bat's wing is not dissimilar to a human arm, with a few notable modifications, especially in the 'hand' and length of the fingers, so you can use your own arm as a basis. I have tried in the past to borrow stuffed creatures and animal skulls from the local museum, but they didn't seem to trust me (I should never have mentioned the word 'dragon'). But give it a try – your luck may be better. Birds are much harder, due to all the feathers that get in the way, but there are more books on birds than on bats, and if you have a falconer among your acquaintances, you have a ready-made supply of subjects.

EARTHSEA

The hero of Ursula Le Guin's Earthsea novels visits a land ruled by dragons. Marine iguanas and the volcanic Galapagos Archipelago were my principal inspiration. The clouds were initially blocked out with a brush, then masked off to equalize the sky behind with the airbrush. To mask clouds I generally take a single layer from a sheet of paper towel and spray it with repositionable glue, then tear it into small pieces and lay them over the existing clouds. The ragged, fibrous edges make natural-looking cloud edges. I occasionally use gouache for the sky if I want it to be opaque and uniform.

◄ GRENDEL SKETCH

Taking time over a theme and letting your mind wander allows many new ideas to occur 'en route', notably here the tattoo-like scars from wrestling with fire-snakes in the depths of his mere. Grendel's face is a sort of cross between a sea otter and a lamprey.

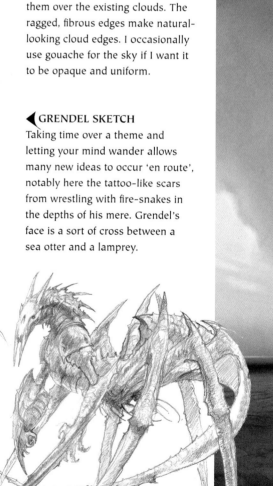

QUAY SKETCH ►

The full body of the Quay alien in 'battle mode'. The game developer wanted a transformed version of the creature for gladiatorial combat. This is a very rough sketch to establish the anatomy and proportions.

'Quay' © Decipher Inc.

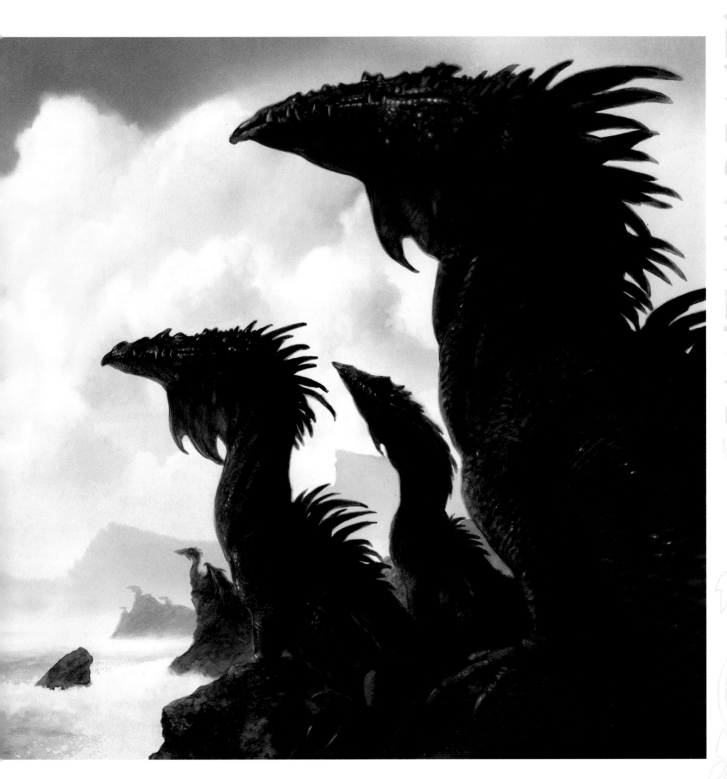

FANTASY BEASTS: NOBLE ANIMALS

Some creatures hold a particular fascination. They may be familiars of the gods, like Hugin and Munin soaring above Odin in his guise as a hooded traveller, or objects of desire such as unicorns and white stags, hunted as if such beauty must be possessed even at the cost of its destruction. Some are embodiments of nature, others are guardians of the otherworld, set there to warn us away or lure us to our fates. Sacred places have watchful creatures too, and it seems there is a mythical animal waiting at every twist in the path.

How to depict them is another matter. Unless they are physically fantastical, they must receive a careful dose of the subliminally anthropomorphic to show their supernatural nature. It is a very fine balance: too much and they look 'disneyfied', too little and they are simply animals in nature paintings. Overly humanizing them is the equivalent of putting pointy faces on toadstools – the fare of nursery rhymes. It is often a question of scale and proportion, and conferring a certain sentience in their bearing and regard, establishing a parity between such animals and ourselves.

UNICORN SKETCH
There is a good deal of unicorn lore about, from Pliny to Peter Beagle, so we all know what unicorns look like.

CELTIC MYTH
Originally intended for a compendium of Celtic myth, this image includes a Green Face, an oak, the Green Knight, a maid with a unicorn, a sacred stag and a stone circle, not to mention Cuchullain, a Merlin-like figure and more.

The characters gaze out at something we cannot see, rather than 'posing for the camera'. Only the wise and knowing unicorn turns towards us.

Ravens are the ubiquitous familiars of wise old men, those who are often bearers of ill news. These two could be Hugin and Munin, but is the figure Odin, or Merlin or Gandalf? I'm really not sure.

The ambiguous figure of the Green Man originated in the Middle East in early Roman times, but flourished in medieval Europe, where he merged with his wilder Celtic counterpart. As a spirit of vegetation he is portrayed as a strange face made of leaves, as he appears on the tree above.

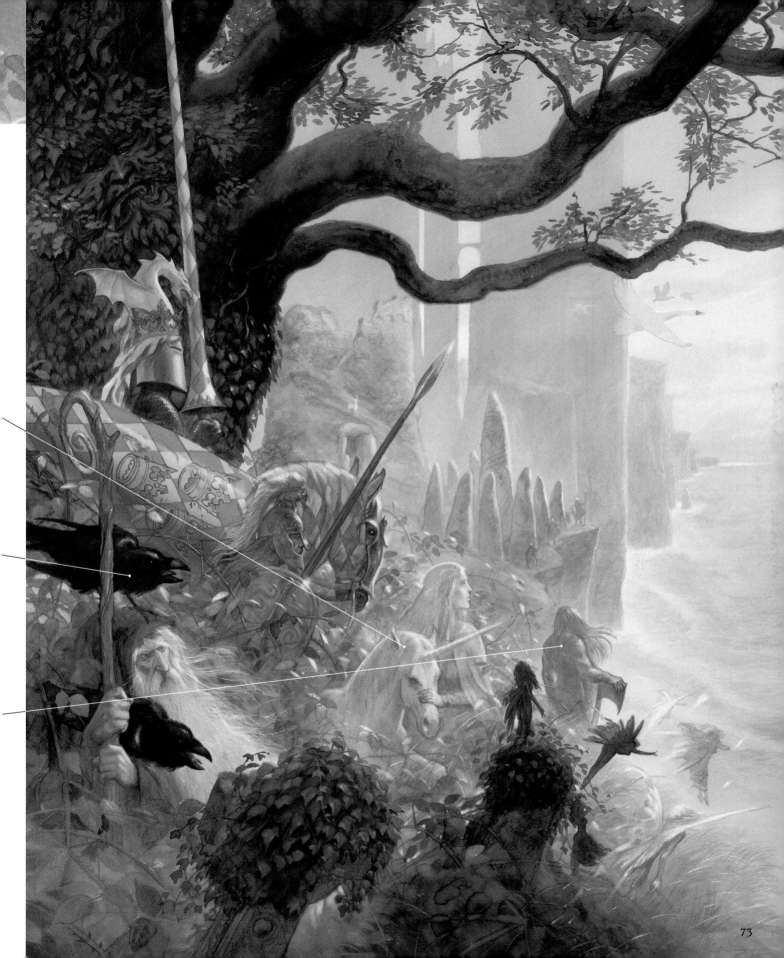

E STUDY: BEOWULF
D THE DRAGON

This painting was originally planned for an illustrated retelling of Beowulf, but I ran late and out of time, and an existing illustration was dropped in and sent off to proof. I was so eager to do the picture I proposed it as a case study for this book. (In the end, it actually did make it into the Beowulf book, just under the wire. That doesn't mean there's necessarily a moral to the story, by the way – meeting deadlines properly is by far the best policy.)

FIRST STAGE INITIAL COLOUR WASH

Blocking out the general colours and, above all, getting some colour on to the whole page. I usually dampen the whole page even if I'm not planning on putting colour on it all, just to keep the paper from being treated unevenly. In scenes where mist is present, the light takes on a most curious tint, so it is worthwhile 'warming up' the lightest tones so that the cooler tones will stand out properly. If it is to be raining in the picture, this is also a good stage to hint at the falling drops by running a large brush diagonally over the whole image.

SKETCHES

Two scribbles for this one. A detail of the positions of Beowulf and his foe (right), and a quicker sketch of the general layout above). Neither need be transposed to the colour work – a few guidelines are enough to start working with.

SECOND STAGE ESTABLISHING SCALE

Figuring out where to start situating the details and working on the different planes and perspectives. Most of this is done wet-on-wet with a wide brush, adding a few details with a finer watercolour brush – the surface of the sea, the cliff edge, the rocks below. Painting barely visible waves often means working slowly forward from the horizon, stroke by tiny stroke. It can be painstaking (and occasionally boring), but getting the scale and distances in at this point is very important. It's best to have pecked away at these aspects all through the image, rather than counting on the human figure to do the job for you at the end.

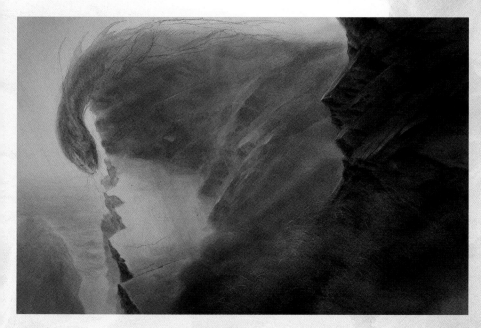

THIRD STAGE BUILDING DEPTH

Working up the volumes of the rocks themselves, and beginning to define the foreground. The sea and the rocks lower left have ended up getting a wash done over them to push them back into the mist a little. The few blades of grass lower right are a little premature, but they don't hurt; occasionally it's helpful to go too far forward in a safe area when you need a little reassurance that things will work.

FINAL ARTWORK

The smoke and smouldering mouth of the dragon are completed. The background has been reworked (yet again) and the waves added, along with the driving rain and wind that push the smoke and sparks from the creature's maw downwards. Beowulf has finally found the right place to stand. The very last things to be added are the reflections from his sword and helmet. It's a good idea not to do this too soon: as they obviously add a lot to the effect of the whole, they should never be done prematurely or with impatience.

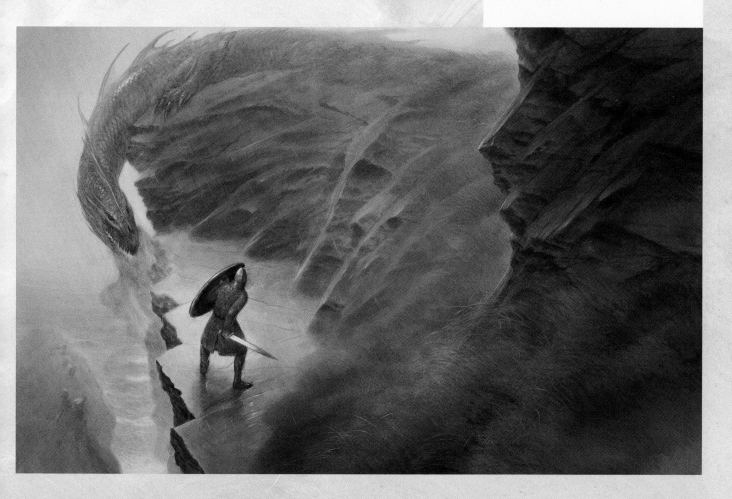

BACKDROPS

The four 'elements' of the ancient world – Earth, Air, Fire and Water – are truly the illustrator's elements. The practice of illustration has as much in common with Empedoclean theory as it does with the colour wheel or the rules of perspective. Juggling all four elements is akin to alchemy.

LANDSCAPES: APPROACHES AND INSPIRATION

n fantasy landscape, mountains are higher, oceans deeper, rivers broader, clouds more menacing. Vistas are grander, groves are sacred, stars shine on vast cities of marble and porphyry. How fortunate we are to have such countries of the mind to wander in.

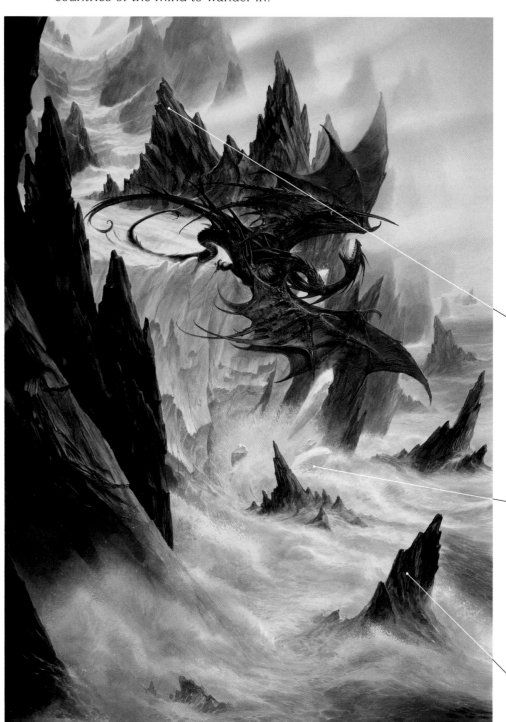

FOOL'S FATE

Cover illustration for *Fool's Fate* by Robin Hobb. The end of Robin's trilogy features a cataclysmic struggle between two dragons, which takes place in an equally cataclysmic setting – the islands of Askjeval, two ragged rocks jutting up from an ever-stormy sea and joined by a glacier. It seemed natural that every element of the image would reflect the struggle of the dragons. Although they are the centre of the action, they appear altogether as an extension of the turbulence of the landscape.

The jagged rocks echo the shape of the dragon's wings, almost like a stop-motion photograph of the movement.

The dragons' struggle has dislodged blocks of ice from the glacier's edge.

The foremost rocks serve to enhance the inhospitable nature of the environment.

GATE OF IVORY

This picture tries to echo the slip-sliding landscapes and juxtaposition of worlds and time that Robert Holdstock's books carry off so well, by incorporating elements from disparate sources and playing around with their scale. The giant head on the left is from Strasbourg Cathedral, the tree growing on it from England. Behind that is a ruin from Scotland. The open-mouthed statue with the fire inside is a Scandinavian sculpture, the roots on the far left are from the Gulf Islands, the leafy giant comes from inside my head, and the huge tree is from our back yard. No, that's not true – it was just to see if you were paying attention. We have something far more mundane, a magnolia.

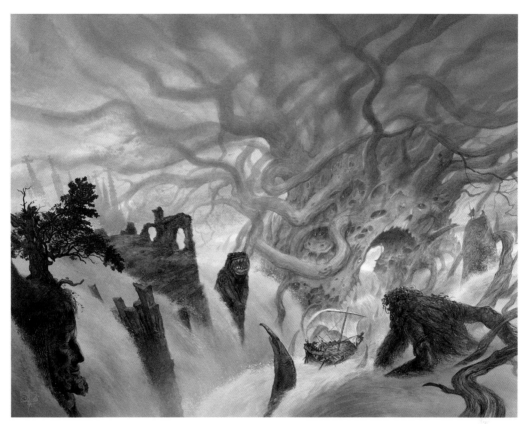

MERLIN

This cover for a book on Merlin (later shelved) uses a landscape on the shores of the Lake of Neuchâtel. On an incredible afternoon with fog on the lake and sun above, I snapped a couple of photos. I've never found the exact spot again. Occasionally a certain landscape will seem to sum up a particular myth or character. Of course it's very personal, but according a little thought and attention to just what draws you to such a choice can help you approach the character himself (or herself). I strongly believe in associating real locations with those places where the mind goes when inventing or enhancing an approach to fantasy. (Of course, it helps if you can find them again.)

There is a well-defined symbolic role to be played by landscape, and rock is its backbone, defined by the forces that went into shaping it. Whichever world one has at hand is underpinned by this, and the nature of rocks should be harmonious with the world they crop out of.

Painting the host of surface textures and keeping track of the volumes that compose a landscape can be quite a job. It can be hard not to revert to a 'system' to render large areas of stone, water, grass or trees. This is really worth fighting tooth and nail, as it reduces your palette to a graphic language that relies on recognition rather than depiction, and you will end up with something far removed from the real thing. If you have, say, a huge tree to paint, start with the area to which the eye will be drawn by your composition, and work on that important section, backed up by photographic reference if need be, until you've captured something of the true likeness of bark. In doing so you will have developed a 'system' of sorts, which will let you faithfully render less important areas without relying too heavily on visual shorthand.

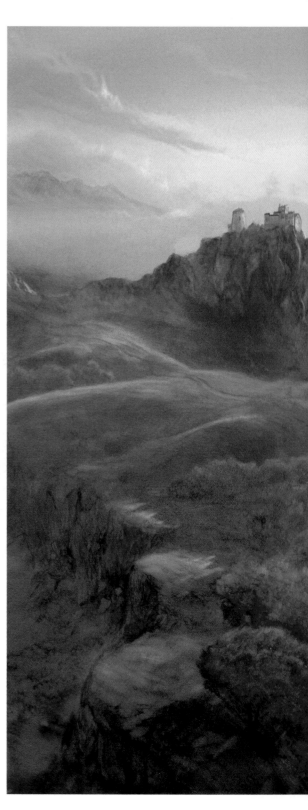

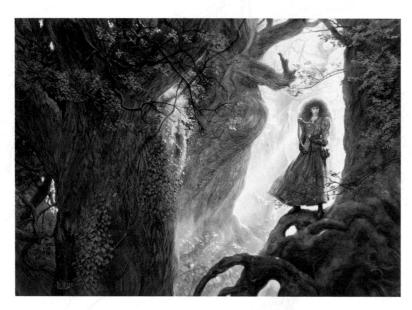

▲ INTO THE GREEN
The main character of Charles de Lint's novel is a personification of the forest – alluring and a little dangerous. The rocks of Betws-y-Coed in Wales were the inspiration for the trees (recipe for tree: just add bark). The arbitrary eddies of forest light and shade mean you can apply whatever degree of atmospheric perspective you wish.

A SONG FOR ARBONNE
The landscape depicts a fictional medieval Mediterranean world. I even made the effort to briefly research the planting patterns of olive groves and vineyards in 15th-century Italian paintings. This was admittedly an aside, but it does illustrate the occasional detour one can make while elaborating an image.

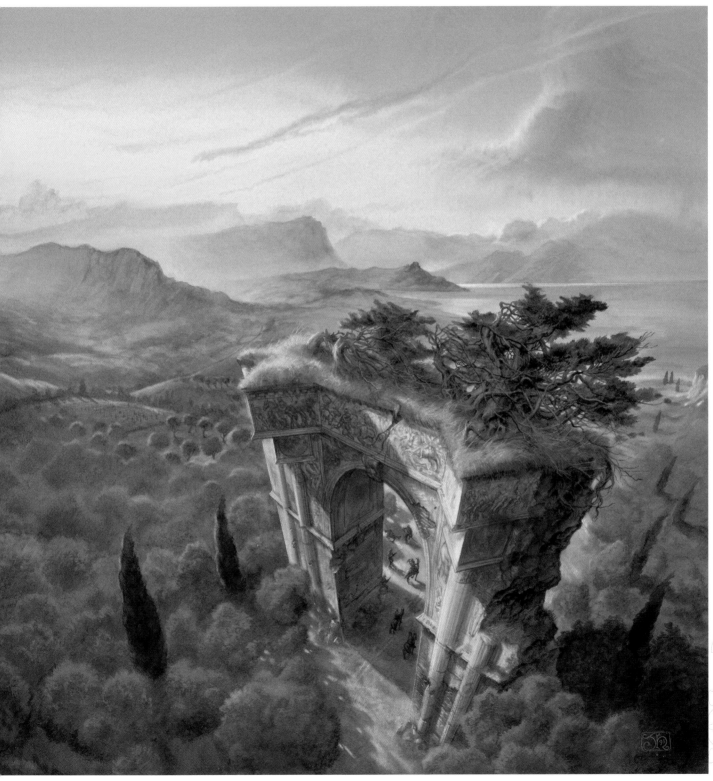

LANDSCAPES: AIR

You may not be able to see air, but you can certainly see what it's up to. Such sumptuous emptiness is a gift to be used generously – the air is full of dust, light, clouds, rain.

Distant, hazy views, of mountains, say, in watercolour are generally best done when the paper is quite wet, so it's best to visualize what you have in mind before you begin. Although you can work back over with drybrush, this can be hard. Distant features can be blocked out wet and details added later, being careful not to compromise the blurred edges. Atmospheric effects are often volatile, and are best achieved with a certain amount of freedom, rather than being laboured over.

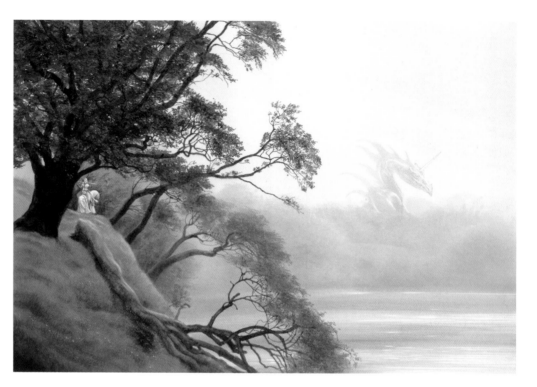

WILLOWS

This is both the opening and closing illustration for a children's book by Claude Clément, *The Man Who Lit the Stars* – the rising and falling curtains on the narrative. Spring and fall often bring the best light, when the sun is low in the sky, and wet grass can be the most intense of greens. When sun and rain are in the landscape together, the most extravagant effects of light and contrast can be found. Landscapes like that are similar to watercolours when they are still damp, or the handfuls of wet pebbles children pick up on the beach. Trying to capture that saturation of tint can be a real challenge.

Willows, from La Ville Abandonée, John Howe © CASTERMAN S.A

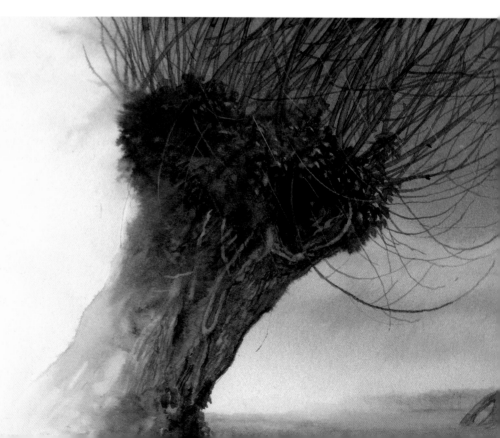

◀ THE RED CROSS KNIGHT

The story of the Red Cross Knight is something of an afterthought in fantasy. Knights have ridden far from Arthur's legendary kingdom into the realms of folklore, on their way to children's literature. The benign-looking dragon and the idyllic pastel setting are reflections of this, a fairy-tale landscape for characters who have lost much of their own substance in successive retellings. There is more depth to the landscape itself than to the inhabitants.

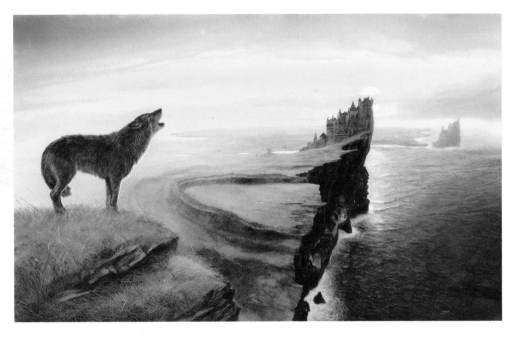

▲ NIGHTEYES AND BUCKKEEP

So much of the incredible range of contrasts of cloud is comprised of minute variations between warm and cool colours of similar density.

LANDSCAPES: FIRE

I have always loved drawing fire and smoke, and my library is full of books on vulcanism. Any flame can become a principal light source in an image.

Rendering such a volatile effect demands taking a deep breath and diving into a very well-dampened area on your paper. As with clouds, the work needs to be done quickly or the spontaneous nature of flame can be lost. Inks and watercolours are transparent, so it's crucial to start with lots of fresh, clean water and paper towels to clean your brushes as you work from the bright yellow heart of the flames to the darkness of the smoke.

SLOW DRAGON

Everything – approaching storm, waves, walls, inexorable belly-dragging progress of the dragon – is moving to the right. Only the dragon's head turns to the left, pulling the eye back into the picture. The narrative, however, continues out to the right, to the next chapter in the story.

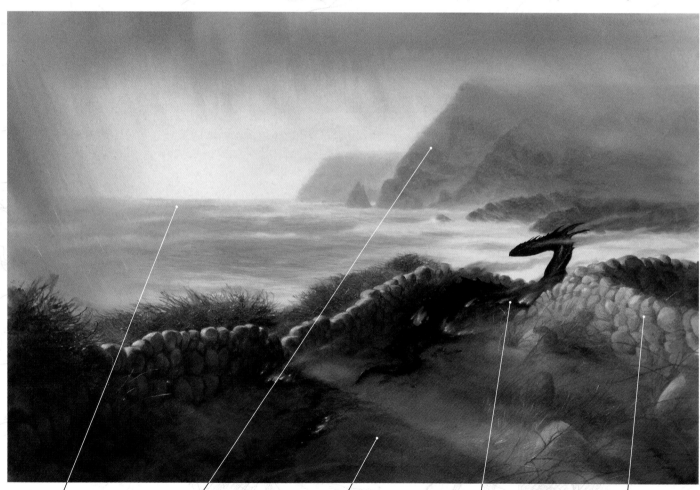

Detail fades quickly to the horizon; texture is used only to intimate the depth of the breakers.

The headlands and cliffs help provide focus by blocking off the horizon to the right, and the blue of the hills brings the attention on to the dragon.

The shadow echoes the line of the coast towards the dragon's head, making a narrow band of main focus.

Sometimes less is more: just a few patches of fire on the grass are enough to give an indication of the power of the dragon.

The drystone wall is very pale – almost white – in the weak light, and its curve out of the picture leaves the plight of the settlement to the viewer's imagination.

▲ FIRE DRAGON

I wanted to explore the theme of vulcanism, with dragons spawned in molten rock. Images of this kind are not technically difficult. Documentation required: a few decent photos of lava. The two distinct light sources – warm (incandescent in this case) and cold – do not mix, so it is worthwhile working from their lightest parts to where they meet but do not really mingle.

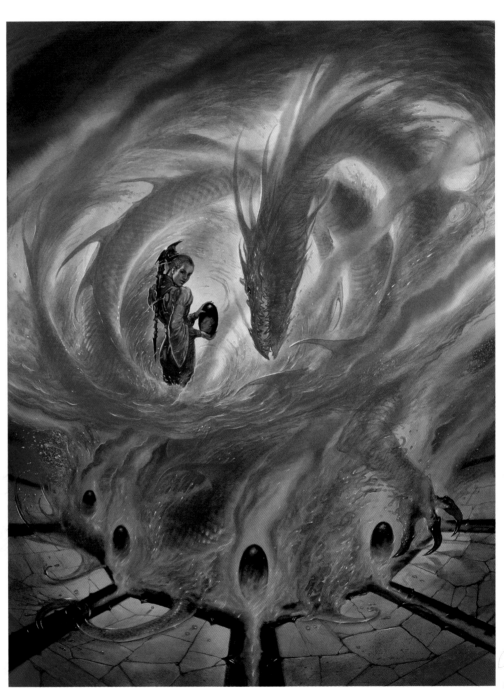

DYADD

The fire is painted on a well-dampened ground, to capture its movement and volume. Black ink will be repelled by vermillion, so flames can reach up into the smoke without being dirtied or lost.

MISTRESS OF THE PEARL

A water spirit dragon imprisoned in a cage of smoke and flame was one of the more novel requests I've had for a book cover. I enjoyed rendering the dragon coruscating and dissolving in his airborne whirling tempest. But fire and water mix with difficulty, and the original is now in two pieces: the paper was far too tensely stretched on the board and split in two right across the middle when I was cutting it free. I would now take both pieces to the scan shop and put them back together in Photoshop.

LANDSCAPES: WATER

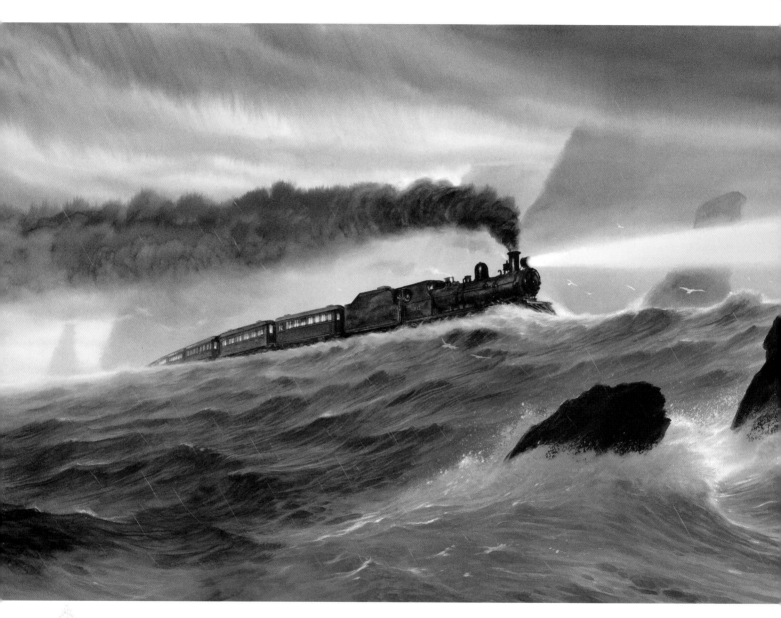

 Water comes in all kinds – mirror-smooth, clear as glass, murky, turbulent or tempestuous. And in all forms – rain, waterfalls, waves, rivers and much more. Depicting this diverse element is always exciting.

An expanse of still water is usually composed of only a handful of tones. A wide brush is useful for blocking in any smooth surface, even more so a reflective one like water.

Toothbrushes are very useful when painting wild water, as you can spatter masking fluid all over and get very realistic splash patterns – on your clothes, in your coffee, on important things

you've left too close. Do not use the same brush for your teeth, and do not use your husband's/wife's/kids' brushes – they will notice. All the old toothbrushes in our house end up on my work table. They last for two or three waves, a river or a flash flood or two before becoming irremediably clogged and then discarded. You need not do all the spattering at once (it can be done in layers), and it is generally a good idea to put down a very light initial wash that will soften the glaring white of the paper.

For rain I generally use a white pencil crayon, unless of course the rain is backlit, in which case scraping with a scalpel can be better; of course, this also depends on the nature of the background.

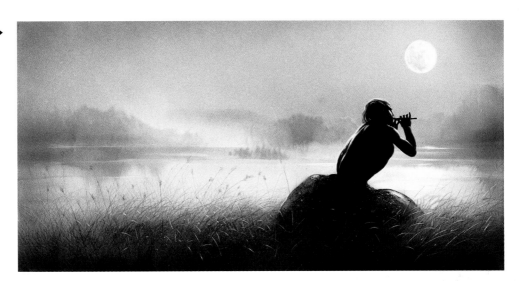

MUSICIAN FROM THE DARKNESS ▶

Still water is often difficult – everything hinges on obtaining convincing reflections. Here, I made the paper quite wet, placed the board at a decent angle, and let the ink bleed and run. Drybrushing horizontally provided the perspective on the water. The highlights and moon were done with an eraser. A hair dryer is needed for this kind of undertaking: to avoid water pooling and drying unequally, and to halt the run of ink when necessary. The musician is me, posing with a ruler in my mouth. *Musician From the Darkness*, from *La Ville Abandonée*, John Howe © CASTERMAN S.A

◀ ROLLING HARBOUR

Cover art for a music CD by the band Elandir. This illustration was enormous fun to do. I needed to keep the waves 'solid' enough to visually support the train while still looking like water. The foreground waves and spray were first done in a warm tone, masked (to paint the water behind), then cooled and darkened with the airbrush. The highlights were added with a hard eraser and a scalpel, scraping back to the warm undercoat.

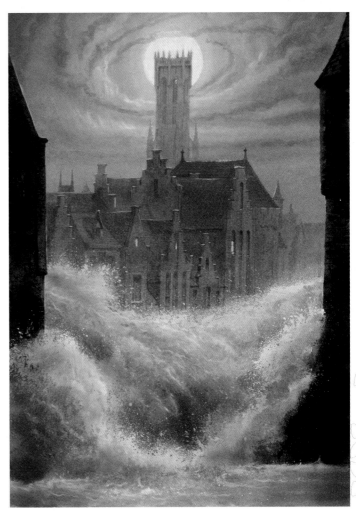

THE RISING SEA

This is the cover illustration for *The Abandoned City* by Claude Clément, in which the king of the (as yet not abandoned) city breaks his word to a humble glassblower. As a result, the sea invades the streets. While the rising sea is an inexorable consequence of the king's arrogance, the stirring-up of the cosmos, reminiscent of the Flood, is not hinted at in the text, though Claude's awareness of what binds us to nature is clear, embodied by the restless sea. Somehow, however, it seemed crucial to me to visualize a purposeful conjunction of the elements as retribution for the oathbreaking. The cascading water was painted using waterfalls as reference, by splattering masking agent with a toothbrush and re-working in coloured pencil. *The Rising Sea*, from *La Ville Abandonée*, John Howe © CASTERMAN S.A

CASE STUDY: ATLANTIS

This illustration is a double-page, full-bleed, full-colour opener for a picture essay on the drowned civilization. After some serious consideration it seemed that there was no avoiding the catastrophic fate of Atlantis, but I did want to emphasize the fact that it was destroyed by Poseidon. Hence the huge and stern-visaged statue of the sea god presiding over the sinking.

SKETCHES

A few constraints are imposed by the book's layout. A title and text will be placed on the left-hand page of the spread, and of course it's wise to keep important elements of the illustration out of the gutter. For more rigorous layouts like this, it is worthwhile sketching in the correct format. I did a first sketch with Poseidon rather too large (below), then placed him in context in a second (above).

FIRST STAGE INITIAL COLOUR WASH

Obviously, in cataclysms of this nature, the sky opens and clouds boil, waterspouts dance and waves churn every which way. With the sketch as reference, I blocked in the sky and a few waves, just to more or less determine the atmosphere. While this may not look like much on the page, it contains (hopefully) the guidelines I need to carry on. There is a limited time for this operation, as the paper cannot be re-moistened indefinitely without eventually disturbing the colours. Squinting at the page from a low angle will allow you to see the zones that are drying more quickly than you would like, and to make sure that no pooling of water occurs, which would result in a hard line along the edge of the puddle. It's good to have a hair dryer handy to head off such problems.

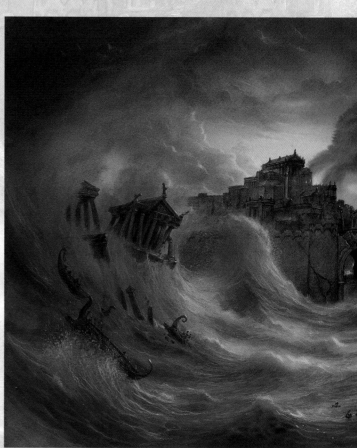

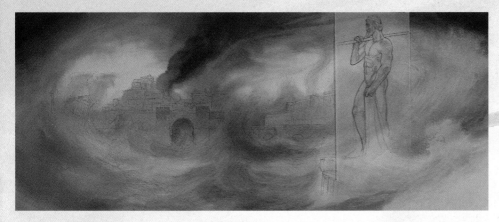

SECOND STAGE SITUATING THE SEA WALL

The city has been sketched in and a horizon line determined. Dampening the whole sheet a second time, I've added the smoke from the fire and started to block out the masses of the water and the waves. Rather than be hindered by thinking of the statue (as he's much darker than the rest, there's no need to mask him off), redrawing him on tracing paper allows him to find the best position and then be folded back out of the way. I've put a vanishing point in the middle of the central arch, which will draw the eye back to that point as well as fixing the surrounding structures.

THIRD STAGE MAKING WAVES

That awful looking sticky latex stuff splattered all over the sea is just what it looks like: awful-looking sticky latex stuff, or masking agent. Quite a lot has to go on for a picture with raging waters and crashing waves. I'm already on my second toothbrush at this stage. Ever mindful of the need to keep a low-contrast wave to the left of the image, there is nevertheless room for dark water to add depth.

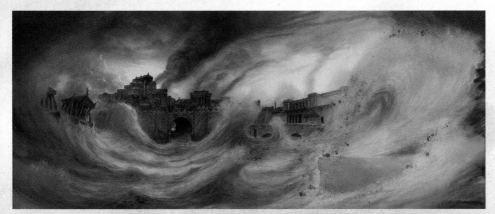

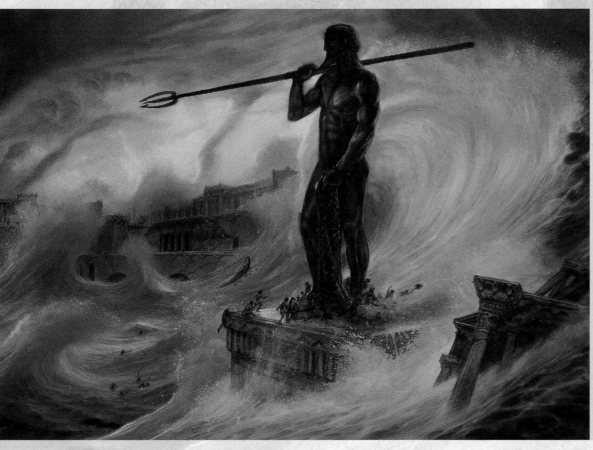

FINAL ARTWORK

I've added Poseidon, built the pedestal under his feet, added fleeing Atlanteans and capsizing galleys, as well as finishing the wave that must support the text. All the waves are designed to bring the eye back around and into the centre of the image again – the visual equivalent of an undertow – so there's no escaping either from the image itself or from the doomed city of Atlantis.

ARCHITECTURE: APPROACHES AND INSPIRATION

To say that I am fascinated by architecture is an understatement. The world has a history of seven thousand years of placing one stone or brick atop another, and everywhere I go I spend spare moments snapping photos and making quick sketches.

I am enraptured by the patterns of paving stones, captivated by corbels, bewitched by belfries. I'm charmed by Corinthian, delighted by Doric, beguiled by Gothic, mesmerized by Moorish, ensorcelled by Art Nouveau. Castles and cathedrals conquer me without siege, monuments arrest me in mid-stride. I find statuary seductive, alleyways alluring, ironwork riveting. (My little word-games are perhaps trying, but you get the idea – architecture is a fabulous open book in large print.) I love all forms of architecture (the exception being modern glass and steel, which, while awe-inspiring, affords little pleasure in rendering it). Architecture, like all human endeavours, is often a summing-up of a culture. This notion came home forcefully when I found myself in New Zealand working on the *Lord of the Rings* trilogy – several thousand miles away from any architecture more than a century or two old.

THE MOUTH OF SAURON ▶
The helmet of the Mouth of Sauron, from Tolkien's *The Return of the King*. The helm echoes in miniature the Towers of the Teeth flanking the Black Gate of Mordor, with their jagged ramparts and crenellations.

◀ **HARPY'S FLIGHT BORDER**
Each foray into an author's universe is a chance to explore a parallel history of art and architecture. The Moorish architecture of Spain, like so many blendings of different cultures, is one of the most beautiful in the world.

GATES OF GONDOLIN ▶
First of a series of sketches for the seven gates of Gondolin, from Tolkien's *The Silmarillion*. Art Nouveau always springs to mind where elves are concerned. The supple lines, inspired by nature and plants, transformed into motifs, seem more elven than any other architecture.

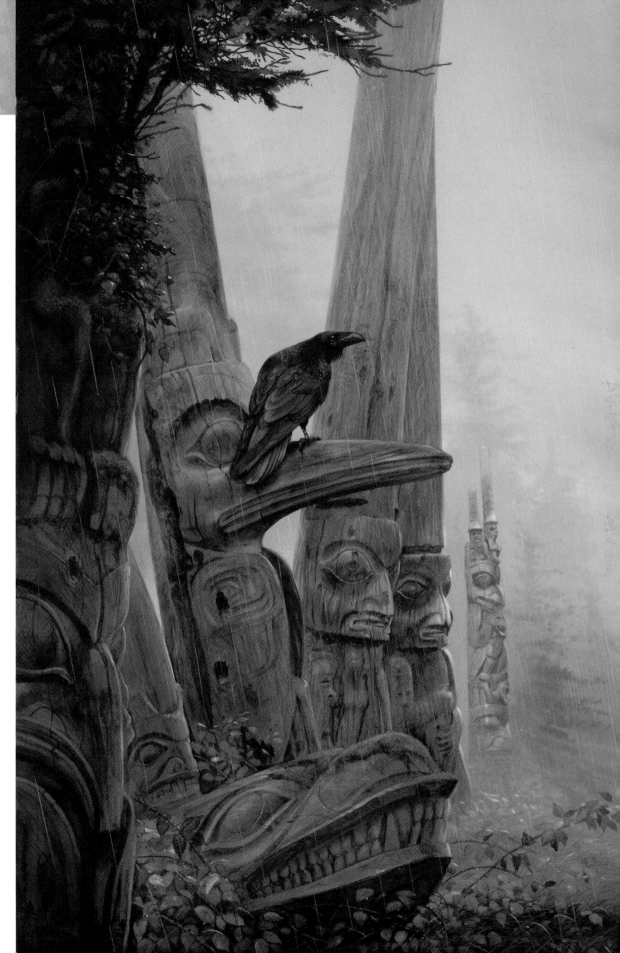

WINTER OF THE RAVEN

When my agent called with the commission to do a painting set in the Pacific Northwest, I was overjoyed. A chance to draw something I grew up with, this is going to be really fun ... It turned out to be a nightmare.

I have strong feelings about Northwest Coast First People's art. Mixed feelings, since I am deeply touched by it (I carved a 30-foot totem out of a fallen telephone pole when I was 15), but of course I can lay no claim to any of it. I've walked through abandoned Nootka villages, a couple of hours by Zodiac from anywhere now. Rotting totems askew in the forest and the long grass. It was eerie: a requiem sung by screaming gulls, a winding sheet of ragged mist. And an unwilling son of conquerors and civilizers in a windbreaker and damp hiking boots, rain on my glasses and in my heart. I'll never forget.

Decades later and thousands of miles away, the raven was no problem, but the totems ... no way on earth to turn up photographs of Haida poles in Switzerland: not a book in any library, nothing in the bookshops – it was awful. I finally got lucky at the local Museum of Ethnology, where I stumbled on what I needed. I've since acquired several books on totems, but will I ever need to draw them again? Better safe than sorry ...

ARCHITECTURE: FANTASY AND REALITY

Building fantasy architecture requires no diploma, no engineering skills, no degree. The construction is not done with quarried stone, moulded bricks or adzed timbers, and the finished building is not intended to house generations of families, but to provide convincing, if temporary, lodgings for the imagination.

Naturally, real architecture convinces because it is real, whether ancient or contemporary, exotic or vernacular. We can admire or disapprove of it, but it is indisputably there. Fantasy architecture must gain implicit approval without this facility. The whole idea is to briefly believe in what you are dreaming up, within the context imposed by the architecture itself. It's a process not so far removed from the work of medieval architects – all those men possessed ideal castles in their minds, but of course they could only rarely be built. However, every version that was constructed is clearly the expression of a given culture.

The grasp of perspective required for illustrating is pretty basic, thankfully. It's really more a question of being able to put your finger on that niggling sensation that something is 'not quite right' and possessing the basic solutions. Of course it is a logical and mathematical process, but far less daunting than it can appear when tackled without method. It's only lines and points, after all.

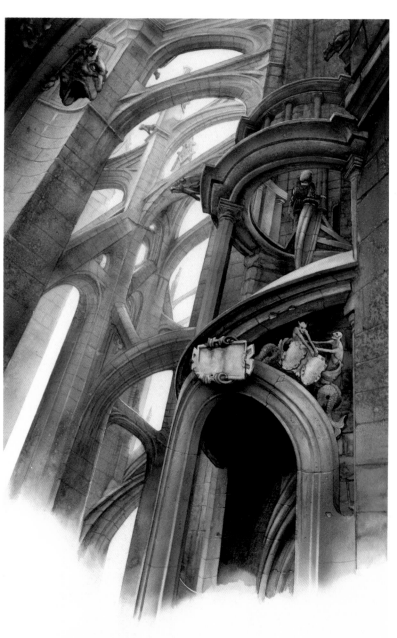

RAVENS

This watercolour is actually a sort of collage. I took hundreds of photos of Strasbourg Cathedral, and simply stuck them all together. The superimposed rows of pinnacles and buttresses in the image are all actually the same row, seen from different heights.

STAIRS

The spiral staircase is a few stories up on the cathedral; I changed nothing. The flying buttresses are from Mont Saint-Michel. Since I worked from a series of photographs taken from quite close up and pinned together, the change of angle results in a bending of perspective. Add to this the twisting stairs and the circling forest of buttresses, and the whole results in a visual updraft spiralling upwards.

THE GLASS-BLOWER'S WORKSHOP

The story this painting illustrates is based on a charcoal drawing by Fernand Knopff, *The Abandoned City*. Knopff did several views of Bruges, all imbued with the melancholy mists of the Belgian Symbolist movement. Any period can be defined by architectural style, building materials and techniques, to determine a 'look' for your fantasy world. Brick is a marvellous material to depict. Endlessly varied, it also occupies that portion of the spectrum where a hint of colour can make it warm or cold.

The Glass-blower's Workshop, from La Ville Abandonée,
John Howe © CASTERMAN S.A

The Melusine, a woman with a serpent's or fish's tail, is a common heraldic motif, often depicted with a double tail. This one was inspired by medieval models.

Paying close attention to chips and fissures, the wear and general patina bestowed by the elements, can help to make fantasy architecture convincing.

I generally treat brick in a manner similar to dragons' scales, either drawing in each block on a lighter ground, or blocking in a whole wall and working up the lighter mortar with a coloured pencil.

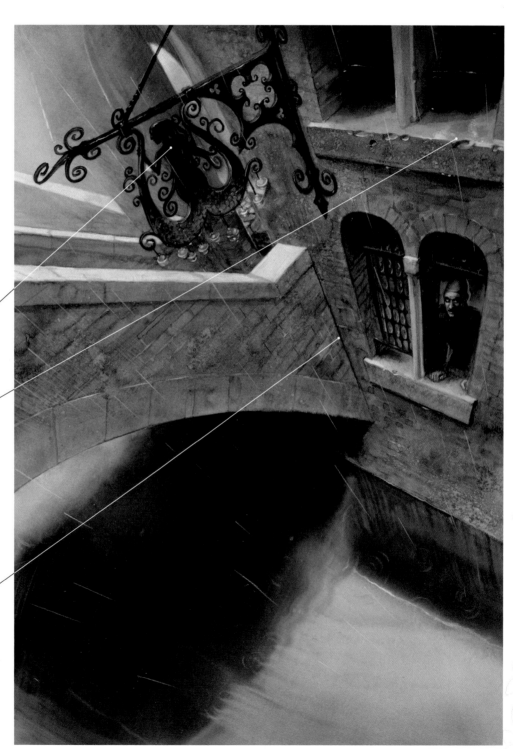

CASE STUDY: THE ARRIVAL OF THE AIRSHIPS

This is the poster for a summer 2007 fantasy-oriented festival in the little town of Saint-Ursanne in the Swiss Jura. It's quite a well-preserved medieval town on a river, with a very beautiful bridge. The image hopefully suggests the arrival of all manner of fantasy elements in the town for the event.

SKETCH
The only sketch for this picture is a scribble on a paper tablecloth, done in a restaurant when the idea suddenly popped into my head. I am working from a photo – although the bridge is of course not that high and doesn't end in mid-span – so it wasn't necessary to do more than sketch the houses and structure of the bridge right on to the paper itself.

FIRST STAGE INITIAL WASHES
Thinking very hard about the Yellow Mountains in China and Milford Sound in New Zealand, I got the paper (it is big) exceedingly damp and worked in a few suggestions of mountains and waterfalls. I wetted the whole paper three times for three successive washes, which is about all any paper will take before too many colours run into each other.

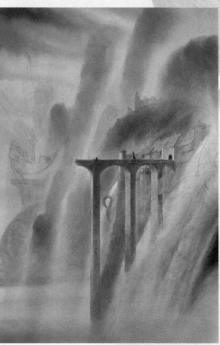

SECOND STAGE BLOCKING AND DEFINING
I have re-sketched the town more tightly, blocked in the bridge and added some clouds at the top, and have continued working up details on the bridge and the town itself, leaving a spot behind the lower dragon's head. (I moved the dragon later, so eventually painted in the light spot.) I've added a hint of cloud and mist and started to work in the nearer waterfalls. Masking off elements such as the pillars is helpful in keeping them vertical. On a whim I decided to add the enormous stone head in the distance – rather close to the edge of the painting, but a little clone stamping in Photoshop will allow the image to be extended past trim edge so hopefully it can stay.

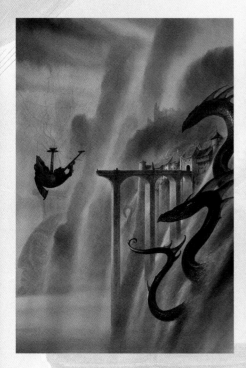

FOURTH STAGE PLACING THE DRAGONS

Options are rapidly becoming indelible decisions. The dragons have found their places (the tail of the lower dragon was decided with a rapid, no-going-back stroke of the brush, more akin to calligraphy than drawing, but this is often a way of retaining energy and movement) and the waterfall in the foreground is properly contrasted. The airships are finding their positions, more or less following the initial sketch. I have also, in a moment of annoyance, run a wash over the far dragon and his waterfall, and erased a lot of white pencil crayon that I had put in prematurely, trying to find the values for the middle ground. The cascade and creature are now well in the background where they belong.

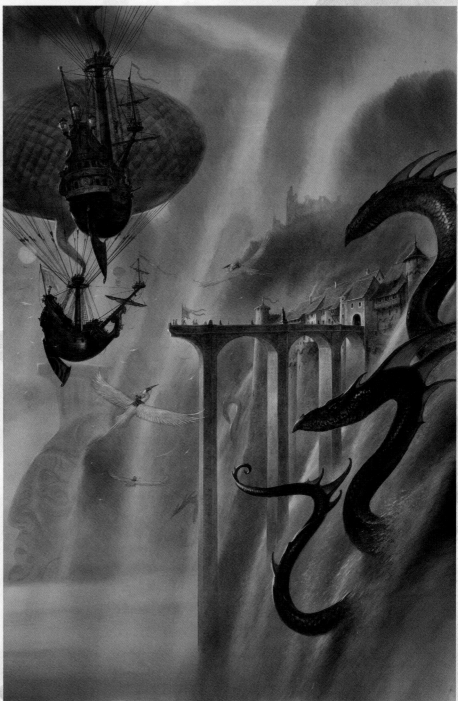

FINAL ARTWORK

The two airships – freely inspired by existing ships and images of early balloons – are in place. They might have been a little better moved slightly to the right, but it seemed important to maintain the distance between the ships and the quay. The empty spot in the middle is now occupied by the birds, added on the spur of the moment at the end, but a certain amount of empty space has been left to accommodate all the text that posters require.

ATMOSPHERES: APPROACHES AND INSPIRATION

I f I had to settle on one reason for drawing pictures, the key word would be 'atmosphere'. Light and dark are the most powerful themes in history, the most constant in allegory and the grandest graphic opportunity afforded to fantasy illustrators.

I would prefer to compromise on graphic straitjackets such as perspective and proportion rather than undermine any opportunity to treat every image as an atmospheric whole. Treating atmosphere with the attention it deserves allows you to exploit every possibility an illustration offers. There is also a pragmatic side to this. As the pot of water one uses to rinse brushes grows steadily more opaque, a little of every colour ends up in every other. While it's crucial that water be clean initially, the residue, both on the palette and in the rinse, adds to the coherence of the whole work.

I have a deep drawer of photos of mossy trunks and branches. You cannot do better than nature does, and it's often worth allowing a composition to be guided by the elements you find.

Years ago, a schoolfriend and I built a costume using a deer's pelvis as a mask, with a tunic made of an old hessian mattress cover, with amazing Celtic spirals imprinted on it by rusty springs. Every now and then some excuse comes up to get out the photos of it.

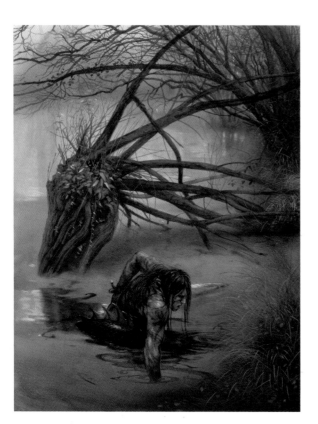

CELTIC DRAGON

The scene is set amongst the marshes that border the Rhine. I've always loved still water with algae or weeds, and the possibilities offered by juxtaposing the different surfaces.

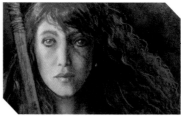

The female character of Mythago Wood, Guiwinneth, is a daydream brought to life from a romanticized Celtic past. This portrait is loosely based on an acquaintance, but mostly on a daydream of my own.

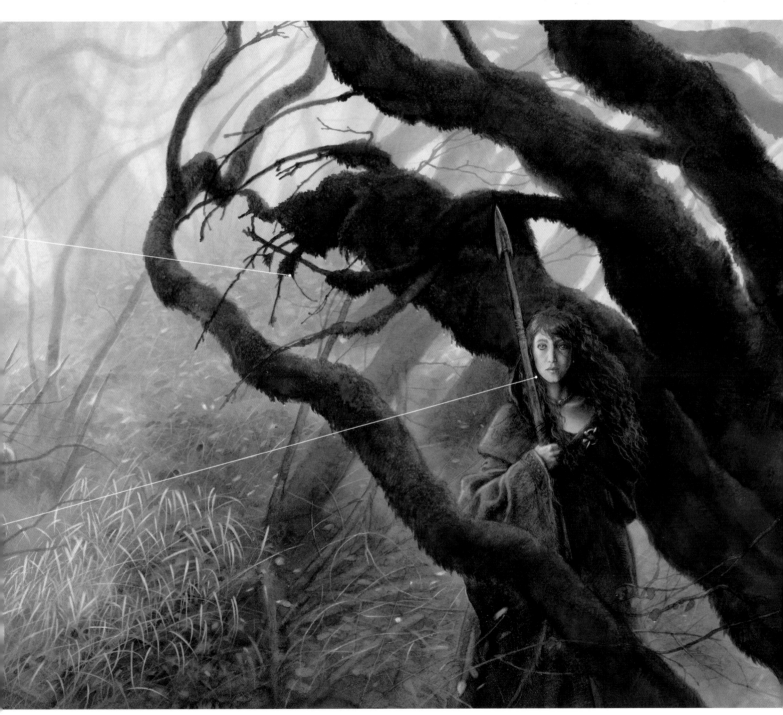

MYTHAGO WOOD

Occasionally authors open wide worlds into which you fall headlong. Robert Holdstock is one of those writers who has stumbled on a unique world that he alone occupies. The landscape is local, along the shores of the Lake of Neuchâtel; all I did was add the characters. I'd used the same landscape over a decade before in 'Merlin' (see page 79), and it's likely that I'll use it again one day.

he balance of light and dark is a powerful symbolical tool as well as a handy pictorial device.

Dark is often mistakenly thought of as black, but it is usually composed of a variety of colours. Dark areas can be indicative of depth, but using black will give you only a flat opaque surface. It is wise to reserve black for surfaces that are black in colour, or for the very darkest corners of your image. The best darkness is made by mixing complementary colours – I'm particularly fond of Prussian Blue and Sepia, as they can easily become a warm or cold darkness, depending on how they are dosed.

Shading doesn't consist only of dark and yet darker areas. It's about the contrast of shade and light, so you always have to remember to make highlights. For this I use mainly white (or light-coloured) pencils in my paintings.

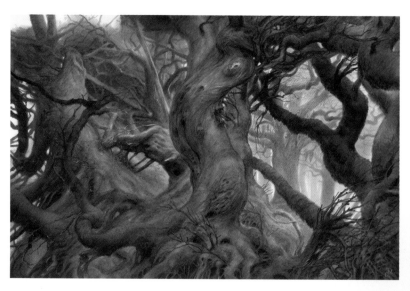

▼ BEOWULF AND GRENDEL

This image was originally done for a board game. Only a small portion of the image was to be used, but it is always good policy to do an illustration that can stand on its own. I decided to shift the perspective to an overhead view – far more dramatic with the embers of the fire in the hearth.

▲ THE PERILOUS WOOD

Forests are always studies in contrast, and often abbreviations of perspective, where line is replaced by juxtaposition of value. This image was done for a book cover, with a large white 'hole' on the right, but I eventually completed it for its own sake. I often paint in the whitened glare of sky visible through leaves and boughs afterwards, letting the light spill over the edges to increase the effect.

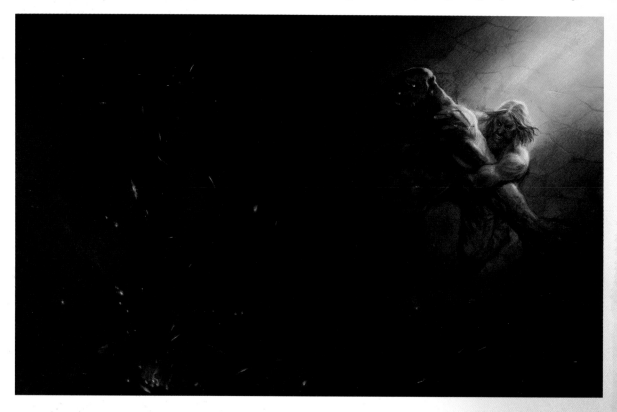

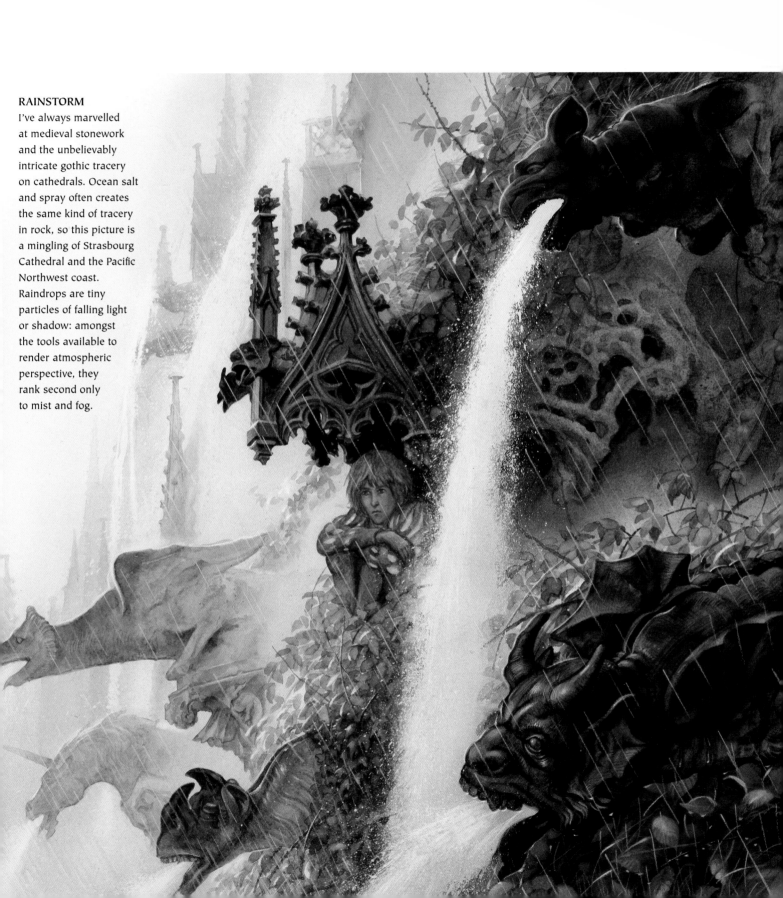

RAINSTORM
I've always marvelled at medieval stonework and the unbelievably intricate gothic tracery on cathedrals. Ocean salt and spray often creates the same kind of tracery in rock, so this picture is a mingling of Strasbourg Cathedral and the Pacific Northwest coast. Raindrops are tiny particles of falling light or shadow: amongst the tools available to render atmospheric perspective, they rank second only to mist and fog.

Collectable cards are to me a relatively frustrating medium. While they are for the most part brilliantly reproduced, the print size is really very small. Nonetheless, a landscape is a landscape and must be created as if it were to be a poster and not a postage stamp. When making a landscape that includes no human characters to provide scale, it is crucial to use a 'lens' close to a standard 50mm, carefully placing the viewer at human height above the terrain.

FIRST STAGE STRIKE ONE

The initial wash, with a colour scheme blocked in. I was fairly careful to work to the sketch I had transferred prior to getting the paper wet. But the result wasn't really satisfying. Somehow, the colours weren't what I had imagined. Also, I had stopped short of blocking in the foreground values, which was an error.

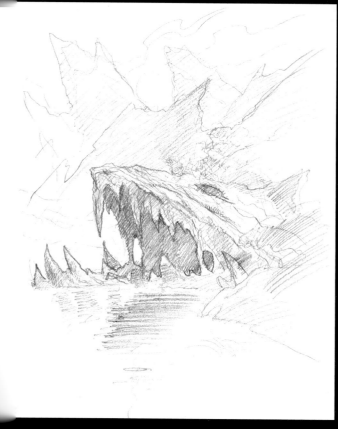

SECOND STAGE SECOND TIME LUCKIER

After staring hard at the first version, I decided that it was far too tame and boring, so I brought out another board, set up my sketchbook so I could see the sketch, and blocked this in on a *very* damp ground, without any pencil work beforehand. It's a shame it can't be left like this.

SKETCH

A fairly rough sketch, but with all the elements in place. This image is for a card in the series *Magic – The Gathering*. Here is the brief: 'This is one of five lands that represent a huge creature that's been integrated into the terrain – sleeping, petrified, hidden, or otherwise neutralized. In this case it's an enormous, evil, wolf-like, 'demon-dog' creature of folklore: a barghest. Show a large, dark cave in a bog that barely resembles the barghest's huge mouth. Behind the cave mouth, a cluster of hills slightly resembles the barghest's crouched body. The general impression should be that the cave only vaguely resembles a huge black wolf with its mouth agape – it shouldn't be too obvious.'

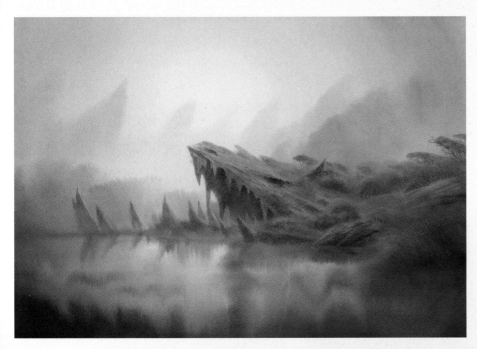

THIRD STAGE ADDING DETAIL

The details are being worked up using drybrush in order to keep lines and zones from forming; a medium-wide oil painting brush is often the solution. Also, putting clear water in the airbrush (with the pressure turned well down) allows portions of the paper to be dampened without forming hard edges when drying, allowing you to work in the middle of that zone for a moment. The tree branches are done in coloured pencil.

FINAL ARTWORK

The last step is basically adding the sun and the highlights. I have darkened the sky a little, added some mist in the background, and a few foreground details, trying not to lose any of the happy accidents from the initial colour wash. Also, given that I'm not beyond falling back on cheap effects, I added a halo and a little lens flare.

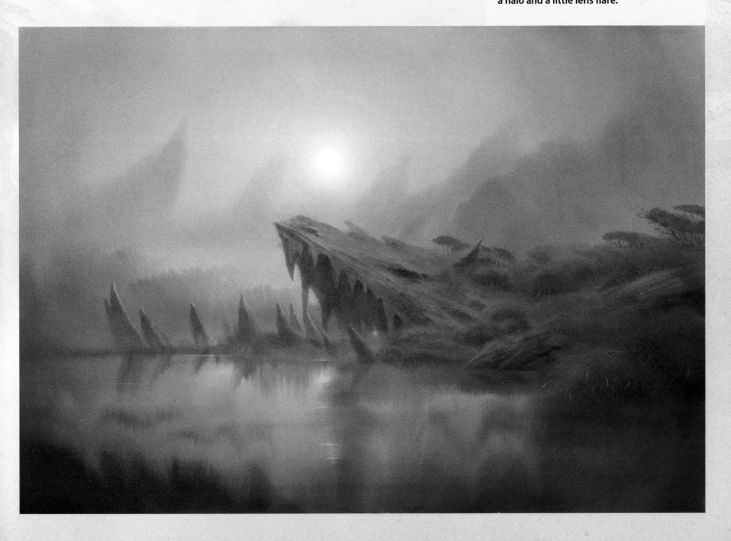

WORKING IN FANTASY

I still get asked what I *really* do for a living and even when I reply that painting fantasy is honest-to-goodness a livelihood, I am occasionally asked why I don't use my talent to deal with real issues. I can only say that I've never been more serious in my life. This chapter looks at fantasy art in the real world, in books, films and other settings, and offers a basic introduction to getting your work published.

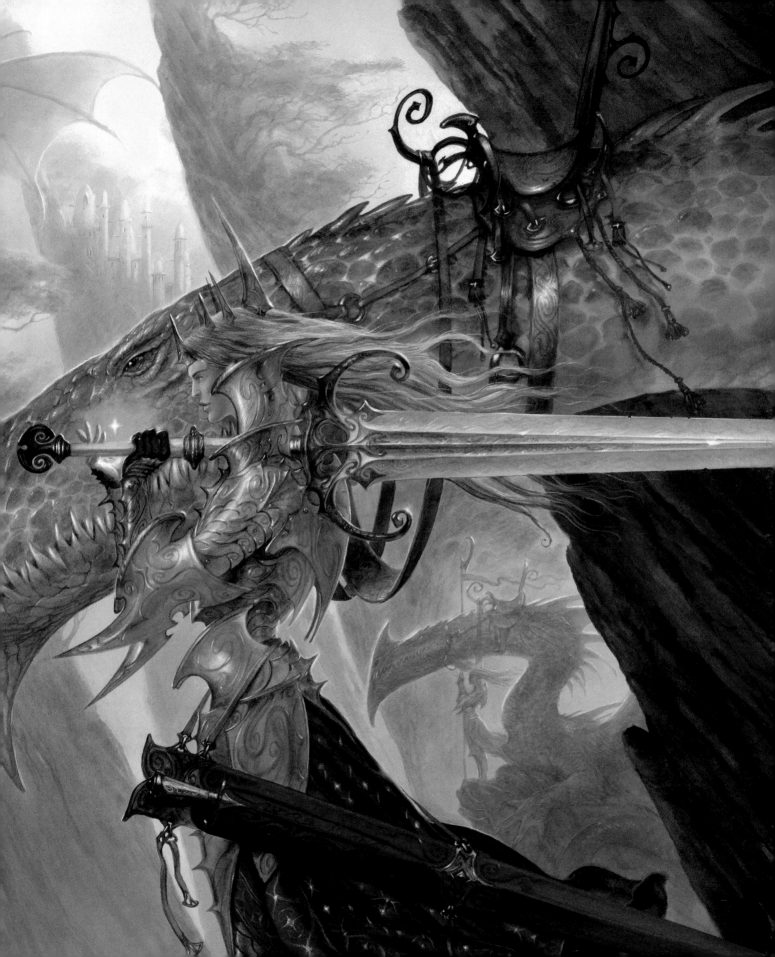

PUTTING YOUR WORK UP FRONT

Presenting your work is secondary in importance only to the work itself. Remember that first impressions aren't entitled to replays, so it's worth doing it well. Naturally, you may be shy – many illustrators are – otherwise you might have chosen a different profession, but don't let that hinder you. Your first encounters may leave you in a bit of a lather, but subsequent ones will be that much easier.

Broadly speaking, presentations can take two forms: you can either put together a wide palette showing your capabilities, or concentrate on what you think represents you more deeply and clearly. The former, while risking looking like a student portfolio, will show that you have a variety of skills, which may land you with a variety of jobs. If you're at ease with changing styles and techniques, this is not a bad way to go. The latter will obviously reduce your potential array of clients, but has the advantage of eventually getting you work that suits you more intimately.

The big appointment

Whatever you do, make your portfolio painless to shuffle through; art directors see a lot of work, so make it easy for them. Never, never apologize for your work while showing it, but remain as relaxed as possible, and make comments only if you see a spark of interest in a piece, otherwise let them do the looking.

Don't over- or under-present your work – run-of-the-mill student work beautifully mounted is as bad as professional work spilling sloppily from a tattered portfolio. You are dealing with professionals – or at least you hope so – and they have seen it all before, but are ever hoping to discover new talent. Keep your presentation simple, smart and clean; it can be in a sophisticated press-book or a portfolio. If you have work of varying sizes, mount the lot on simple sheets of sturdy paper (not mat boards) to unify the presentation. Plastic sleeves will protect it and present a homogeneous format.

Have something you can leave with the person you see: this can be a card, a printout with your details and a few illustrations, or a CD. Take their card. Do not leave originals with anyone you have only just met – if they try to insist, say you need to get the work scanned or show it to someone else, and that you will send them a file or a printout.

Afterwards

Don't be discouraged if the response is a polite refusal or a 'come-back-next-year': all this means is that they don't need your skills that month or for that particular publishing schedule. If you got along well, send in printouts of new work for a couple of months, with a note saying what a pleasure it was to meet them.

Inexperienced illustrators often aim for editors who have just published a book that appeals to them. These are probably the last people to approach, as they've just done the book and may not do a similar one for years. (If it's part of a series, however, this is different, and the same may be true with a specialist publisher.)

Don't sit by the phone or lurk in the hallway waiting for the post; it's not constructive. Of course you want news, but you should be prospecting widely and knocking on many doors, not fretting about one or two. And don't worry about editors stealing your work: believe me, anyone in their right mind prefers a happy illustrator illustrating away to a disgruntled person they can only rip off once (unless you have a terribly poor memory).

Why is an agent useful?

The answer is very simple: selling yourself and your work is hard, and it can be a job in itself. Either you go where the work is or your work goes there for you. The first is not always possible, but an agent will ensure that the latter happens.

Good agents keep in touch with their clients, make regular visits, update portfolios regularly and of course provide a guarantee of sorts that you are a safe bet. In addition, agents aren't afraid of mentioning the 'M' word – money – and usually what they claim as commission is compensated for by the fact that they won't accept your being underpaid. And besides, if you don't want the job, you can always refuse.

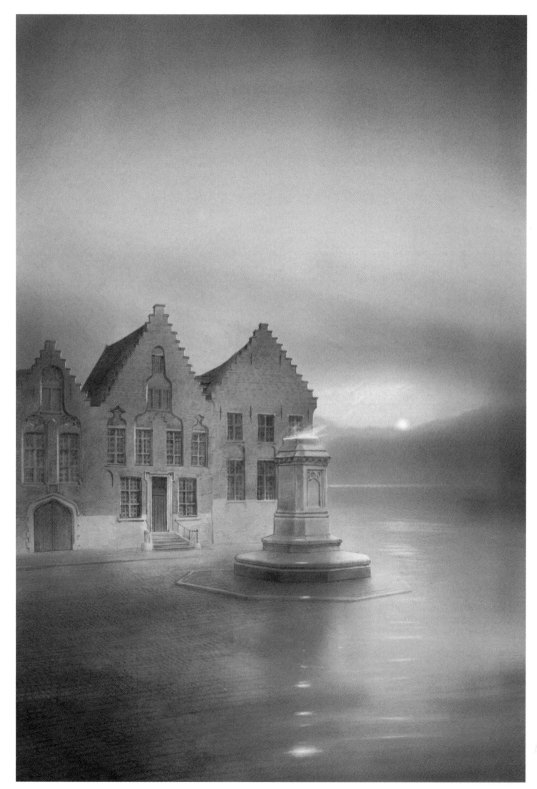

TRISTAN AND ISOLDE

The image was created for a book on dragons. (Yes, there is a dragon in the story of Tristan and Isolde.) Rather than focus on yet another scuffle between a knight and a dragon, I decided to favour the tragic couple, with the dragon as a lurking afterthought in the border.

THE ABANDONED CITY

All should recognize the marvellous pastel by Fernand Knopff, the Belgian Symbolist who produced a number of exquisite and melancholy paintings of Bruges. The painting has always struck me, with the empty pedestal and the sea lapping at the cobbled square. I sent a postcard of the image to Claude Clément, a Parisian children's author with whom I had worked before, and asked if she would write a story for it. We went to Bruges, where I sketched and took photos, and the book was published by Editions Casterman. This is my rendering of Knopff's painting, basically unchanged, although I did delete the odd post-Renaissance addition from the houses. I enjoy anchoring fantasy in real places; it's an opportunity to strip away centuries of urbanism and discover the spirit of a place. *The Abandoned City, from La Ville Abandonée,* John Howe © CASTERMAN S.A

orking freelance is no easy undertaking. (Any independent will regale you with stories of being cheated, broken relationships, both business and personal, unpaid bills and mysteriously invisible creditors.) It takes a combination of sensitivity and business sense, an open attitude and a hard-sell approach: very much a contradiction in terms.

Would-be illustrators starting out generally evolve amidst a public consisting of family and friends. Stepping out of that milieu is both humbling and exhilarating – you're no longer the family star or the talented kid on the block, you're suddenly in a world of peers, most of whom are probably better than you.

But there is a 'magic' moment, though it is hard to know when it has arrived, when you can start expecting to be paid for what you do. It is very hard to know what to charge initially. (And believe me, it does not stop there: it took me decades to separate the human relationship with a client from the money side of it. It can be very hard, believing you're jeopardizing a working relationship over money, because – like it or not – not just the money is involved.)

I am miserable when all I get in return is a cheque with no note saying the work is appreciated. It's like dumping the job in a well.) Also, no matter what your rates may be, publishers have budgets. You can't always get what you want. Much of the job is determining a decent return based on print runs, possible sales, cession of rights, exposure, and so on; calculating a fee can often be quite difficult. Generally, the less you relish doing the job, the more you ask.

GANDALF THE GREY
The original painting of Gandalf was stolen, along with several others, from an exhibition several years ago. It has not been recovered, and I've always declined requests to repaint it. Instead, I commissioned Oscar Nilsson, a remarkable Swedish sculptor and model maker, to create a Gandalf based on that image. (One day, I'll very likely paint another Gandalf based on Oscar's sculpture.)

While illustrating may not always pay the bills on time, you are doing something unique; something only you can do. It's worthwhile considering that. If it cannot occupy the major role in your life, then find another spot for it. Don't lock it away and try to forget about it. If you feel the need to make pictures, then it is not just a whim – it's a part of your balance as a human being.

Working practice
When you do an original piece of art for the publishing world, for an agreed fee, the original is yours. (Film work and advertising is often work-for-hire, and the original will most likely belong to the employer.) The publisher is buying the right to use the image for a specific purpose, such as a book cover. There may not be a contract if you are working for a flat fee and not royalties, but you should still get something in writing. There is no such thing as a 'standard' contract you are obliged to accept, and you can ask that it be modified. Once you have signed, however, you should stick by the terms, even if you capitulated due to timidity or inexperience. You need not make the same mistake a second time.

There is a fairly strict protocol to delivering sketches and final artwork. Once the sketch has been approved, and the artwork is based on that sketch, the editor should not ask you to change details that were clearly set down in the sketch. For example, if the girl fighting the dragon has long windswept hair and you have clearly indicated that in your sketch, they should not send back the finished artwork and request she have a braid. Depending on changes, a second sketch may be requested, but you should have a clear road ahead when it comes to the original. On the other hand, don't make spontaneous changes without notifying the editor: stick to what you have sketched.

Respect deadlines. Delivering late places you in a poor position, so deliver on time (pot calling kettle black here, as I am almost

TOLKIEN POSTERS
IMAGES OF
MIDDLE-EARTH

SIX PAINTINGS BY JOHN HOWE

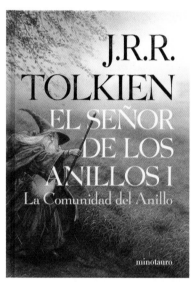

J.R.R.
TOLKIEN
EL SEÑOR
DE LOS
ANILLOS I
La Comunidad del Anillo

minotauro

POCKET

TOLKIEN

반지의 제왕

J.R.R. 톨킨 · 완역판

Η ΜΑΓΕΙΑ
ΤΩΝ ΜΥΘΩΝ

ΤΖΟΝ ΧΑΟΥ
Ο Ζωγραφος του Αρχοντα των Δαχτυλιδιων

Προλογος του Πιτερ Τζαξσον

Εκδοσεις Αιολος

always late). Generally editors allow a margin of time, but don't count on it. The deadline may be just that.

If for some reason a piece of artwork is refused, you should still be paid, but do not expect the full fee. You are of course free to sell your picture at full price to someone else, so it is rarely lost. If a commission is refused after the sketch stage, one third of the fee is normal compensation. I have had projects die after doing a few sketches and heard surprised comments about the temerity of asking to be paid for them. If you have no contract, file that information away. It's a small world, and one day they may be in touch again for another job, when you can say: 'Speaking of sketches, remember ...?' and tell them to get lost unless they own up. Generally, though, editors like illustrators and want to do well for their work, so this does not happen so often. Those who rip you off have no intention of ever working with you again, and you are better rid of them.

▲ GANDALF THE GREY
Perhaps my most ubiquitous image, Gandalf the Grey has appeared in many places (he is always in rather a hurry), often without either my or the publisher's permission, and has been repeatedly pirated on the most unlikely articles worldwide.

THE
LORD
OF THE
RINGS

J.R.R. TOLKIEN

BOOK ILLUSTRATION

You can't judge a book by its cover, or so it's said – but prospective buyers can and do. Each cover is meant to state loudly, 'Pick me up, I am far more interesting than the other books. BUY ME!' A striking image can draw the eye from across a room.

A manuscript may be cumbersome to read, but if you have been commissioned to do a cover it is really important to find the details (such as hair colour and length, straight or curved sword, black or red dragon). However, a collection of details does not make a cover, and a read-through of the whole book, unhindered by note taking, will give you an idea of the tone and atmosphere of a story. Some cover

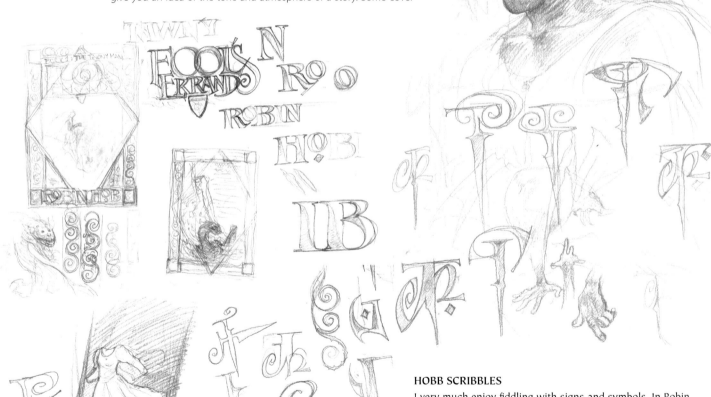

HOBB SCRIBBLES

I very much enjoy fiddling with signs and symbols. In Robin Hobb's trilogy *The Tawny Man*, abandoned stone obelisks called 'skill pillars' allow brave individuals to be teleported from stone to stone. The theme was enticing, and resulted in doodling to find an appropriate set of symbols. I would happily have designed all the skill pillars in the land. (I also found an attractive new signature on the way – you never know where a skill pillar will lead you.) The three Robin Hobb series I've worked on have decorative panels around the cover artwork. These remain the same throughout, new images being dropped in for each novel. The 'ghost dress' floating to the left is for the spine of another book (see opposite page).

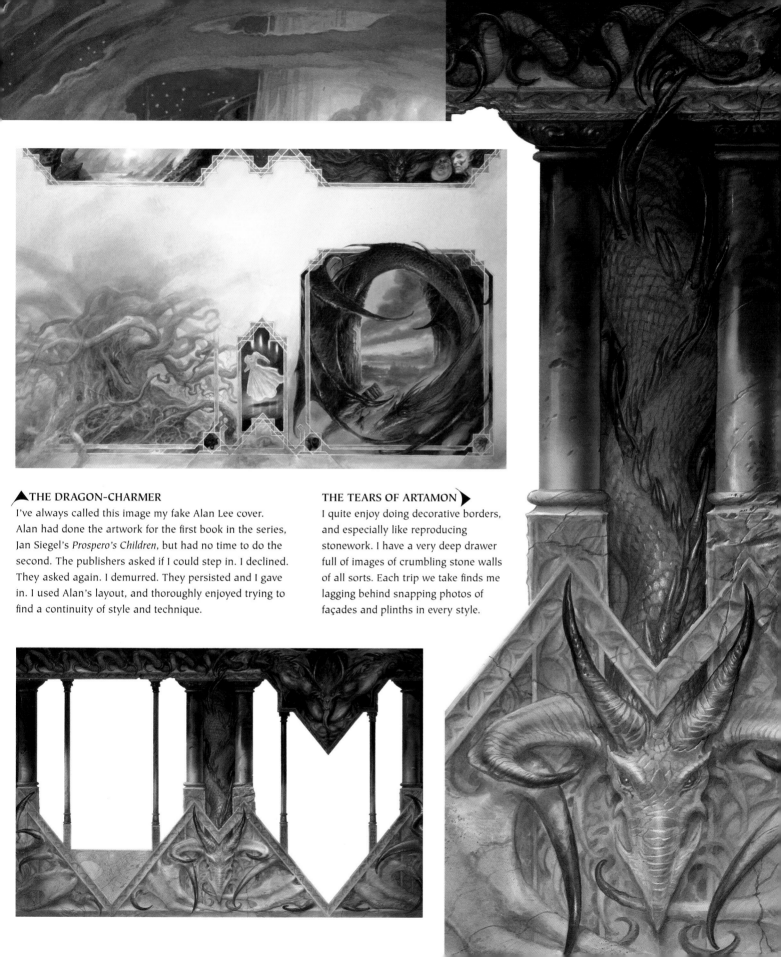

THE DRAGON-CHARMER

I've always called this image my fake Alan Lee cover. Alan had done the artwork for the first book in the series, Jan Siegel's *Prospero's Children*, but had no time to do the second. The publishers asked if I could step in. I declined. They asked again. I demurred. They persisted and I gave in. I used Alan's layout, and thoroughly enjoyed trying to find a continuity of style and technique.

THE TEARS OF ARTAMON

I quite enjoy doing decorative borders, and especially like reproducing stonework. I have a very deep drawer full of images of crumbling stone walls of all sorts. Each trip we take finds me lagging behind snapping photos of façades and plinths in every style.

commissions come in the form of a brief – a short description of some pertinent images, designed to let you know what the editor would like to see on the cover, perhaps with some comments from the author and often accompanied by a cover layout, complete with title copy and dimensions.

Sometimes a cover brief can live up to its name in an unsettling way – the shortest I have ever had was: 'Subject: Elves. Treatment: Fantasy.' Here is another: 'John Howe as artist. Tree border to bleed into the front cover from the left side, covering the spine and back cover. Front cover image, a grassland background impaled by a cavalry sword. Details to come from author.'

I prefer it if the images leap straight out of the text. Many authors are visual writers, and the images therefore come easily; others are much less so, and it can be a struggle to find an image in a text. You may be able to go straight to the author for information, but do this only if you have the editor's approval beforehand.

EMBOSSED LORD OF THE RINGS LOGO

My love of lettering dates from school, where I designed banners for school events, and later painted signs to pay for art school.

▼ THE AMBER SPYGLASS

This illustration was done for the cover of Philip Pullman's novel. It was turned down. So I did it again. That was turned down, too. This was one of the few times I have had a cover refused, and certainly the only time twice.

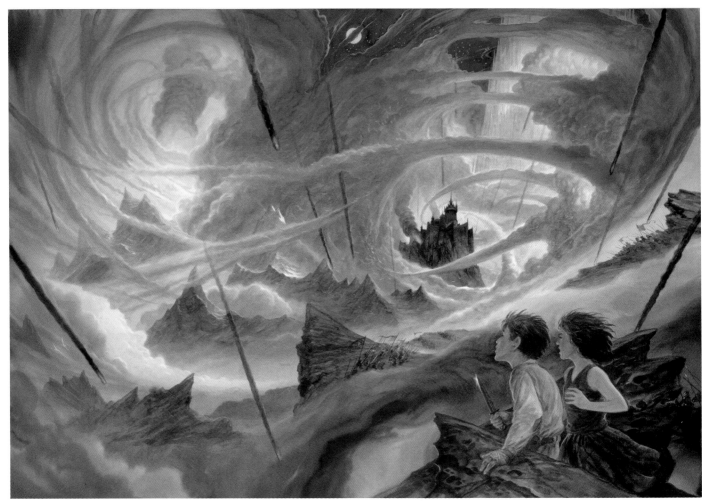

YVAIN'S MADNESS

Spurned by the woman he loves, the knight Yvain goes mad with grief and retreats into the forest. Though the focus of the picture, he is isolated and remote: the oppressive canopy of the tree clinging to the precipice and the fathomless fog express his state of mind.

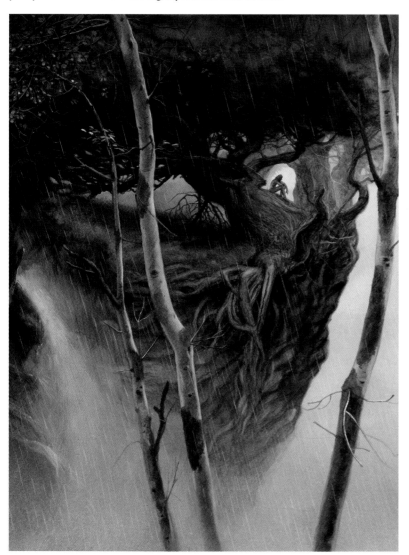

Ideally, while your image should leave room for the contingencies of the layout (however constricting and limiting this might seem), it should not be a concentration of detail on an otherwise vague and empty ground; it should function on its own, and not be ruined by the intrusion of texts. In addition, it is always advisable to finish your image completely, regardless of what will eventually appear on the book cover. Every image deserves that kind of care, and you may well be able to resell the rights in the future.

SAFFRON FOOL

This is more an elaborate doodle than an actual illustration. It began with a spiral and ended up with a bit of a story attached.

Words and pictures

Illustrating a book is a rather different undertaking. The narrative is the primary guide, and the images should possess a narrative logic of their own. Moreover, with children's books, it is mandatory that the image and the text to which it refers be on the same double spread. Children's books are a vocation in themselves.

Graphic novels

These are another member of the extended family of illustrated books, perhaps the border region between the kingdoms of illustration and comics. Less picture-intensive than comics, they nonetheless impose a certain strict discipline (the characters should look the same throughout, for example), which may or may not appeal. Many artists are able to navigate with happiness between the two.

THE BIG SCREEN: SET DESIGN

On a film set, construction is done with the materials of illusion – plywood, polystyrene and paint. Curiously, fantasy architecture, although by definition a negation of reality, has to obey an inflexible set of rules. While free of the mechanical and structural contingencies of real architecture, it must overcome the obstacle of believability.

A leap of faith is required for a fantasy world to appear real on the screen, and any element that hinders this transition is unwelcome. The best compliment I can imagine for it is that it should not be noticed, because it is participating so fully in the storytelling that it draws no attention to itself. The homeliness of Bag End, for example, plays a crucial role in the 'selling' of *The Fellowship of the Ring* (and by extension, the remainder of the trilogy) to the audience.

Fantasy worlds are usually based, at least loosely, on past civilizations familiar to us through myth and history. To organize any excursion into the land of make-believe, the designer needs to provide not so much a palette of recognizable objects as an accumulation of recognizable technology applied to an alternate reality. It is not simply a question of lifting morsels of masonry from existing sources and adding a little mortar (Tinseltown Ready-Mix) to bind them together. Such a process results in a theme park, not a convincing movie environment.

On the other hand, the real world is itself distorted and re-arranged by passage through a camera lens. Most people have had the disconcerting experience of seeing a familiar place for the first time on film: it suddenly acquires new perspectives and proportions. We gradually integrate this new vision with our experience and accept both versions, but what about places we know only through the camera lens? Even environments so foreign as to be practically fantastical are accepted at face value because of the context in which they reach us. Within the reassuring framework of a documentary, we are willing to accept extravagance and exoticism because we perceive them as real.

ELROND'S HOUSE
Of the numerous designs I did for Elven architecture, this is one that I prefer. Scandinavian and Slavic Art Nouveau were of course the principal sources of inspiration, using a number of themes possibly dear to Elves. Ships, swans, waves and trees, with proportions inspired by Alphonse Mucha, were the guiding lines.

▶**BARAD-DÛR**
I had already designed the Dark Tower and the Fell Beasts earlier on, so this illustration was an opportunity to revisit the Nazgul against a wider background. The river of fire running parallel to the road to Mount Doom is borrowed from one of J.R.R. Tolkien's own depictions of Barad-dûr. The plain of Mordor is twisted rock in swells and waves, as if a rough sea had suddenly turned to stone.

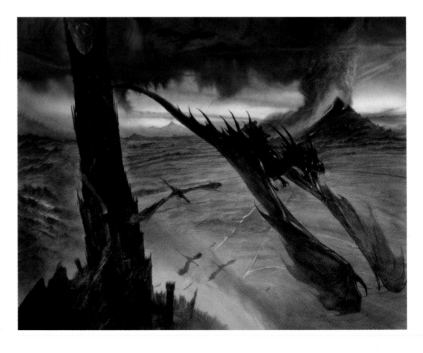

▲ BAG END

Bilbo's home is the grandest in Hobbiton, but like many old houses, all is not perfectly symmetrical. I'm quite proud of the little sliding shutter over the window on the left, and the fact that one corner shows the remnants of arches.

BILBO'S BACK DOOR

Beside the world-famous round green front door, Bag End of course has a back door. (I also designed a secret door, but it was of course never built, and wouldn't have been visible anyway.) The designs for the hobbit houses were endless variations on simple shapes. Thinking in terms of the materials used and staying true to certain motifs and design elements will usually lead in the right direction.

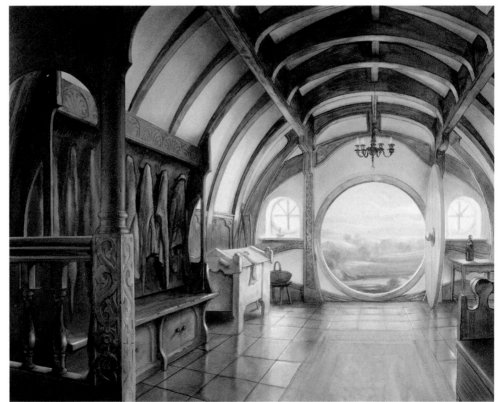

A HOBBIT DWELLING

This image was commissioned for the cover of a map of Bilbo's adventures. It draws on several influences: the description by Tolkien, of course, but also a love of Norwegian stave churches and Scandinavian Jugenstil. Several years later, Peter Jackson said: 'I know what the hall looks like, but how about the rest of the place? Can you just do an about-face and draw the other rooms?'.

THE BIG SCREEN: SET DESIGN

Fantasy film environments do not have this advantage. They have no reality beyond the internal logic of the film, but must nevertheless force acceptance at face value. Our experience of film prior to computer technology told us landscapes had to be real, since physically constructing a wide landscape was near impossible. Now, as the sky (and beyond) is the limit, the threshold of credibility is not so lightly passed without stumbling.

In most cases, fantasy elements are nestled in real environments, or a real environment is pieced together around them. The harmony of this relationship is crucial and must be carefully managed, far in advance of post-production compositing. In interiors, the 'real' may be present in the materials used and the views glimpsed beyond windows or ramparts, but the real world really penetrates the world of fantasy concept art when actual locations are chosen. Naturally, the choice of location is based on the 'feel' or atmosphere created by the concept art, but the two rarely match exactly. Other factors – accessibility, rights of way, budget – generally carry far more weight. More often than not, the original concepts must be adapted to fit the lie of the land.

Rather than being an inconvenience, this is actually the best and final exchange between fiction and reality. The concept work can become, rather than a pure flight of fancy, the equivalent of an apprenticeship in a foreign culture. The acquired knowledge (fictitious, but nonetheless coherent) allows the designer to undertake the engineering required to adapt the idealized structure to the contingencies of the terrain, accepting the intrusion of reality into the design process. This is the best way to avoid the 'designer's dream' look, the deadliest trap into which you can fall.

THE ENDLESS STAIR

In the films the Endless Stair was placed directly opposite the causeway leading out of Minas Morgul: the idea was that the hobbits and Sméagol would be dangerously exposed when the army issued forth. The overhanging rock creates a visual whirlpool of vertigo dragging at the desperately clambering hobbits.

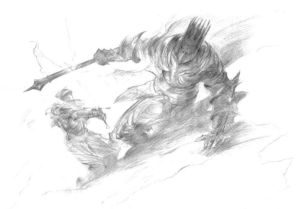

THE BREAKING OF NARSIL

This scene was originally sketched out as a possible fresco in Rivendell, but is rather too focused on the action and not sufficiently on the decorative elements. One of the ambitions for the movie was to create a proper armour for Sauron, who was to appear in the prologue.

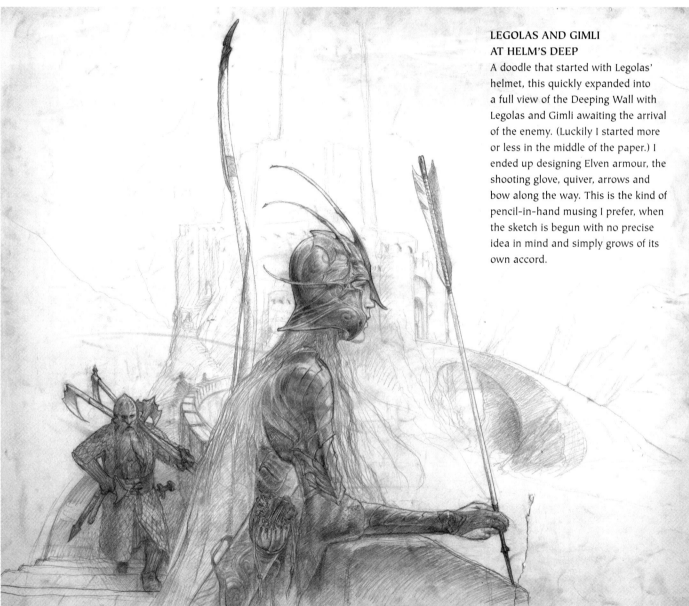

LEGOLAS AND GIMLI AT HELM'S DEEP

A doodle that started with Legolas' helmet, this quickly expanded into a full view of the Deeping Wall with Legolas and Gimli awaiting the arrival of the enemy. (Luckily I started more or less in the middle of the paper.) I ended up designing Elven armour, the shooting glove, quiver, arrows and bow along the way. This is the kind of pencil-in-hand musing I prefer, when the sketch is begun with no precise idea in mind and simply grows of its own accord.

◀ THE FOUNDATIONS OF BARAD-DÛR

The full drawing (this is a detail) was several yards across, and took hours to draw. This enforced delay is valuable: the mind is always just an element or two ahead of the pursuing pencil, and the design has time to grow and change throughout. It's a process rather like discovering a landscape through heavy mist, as the wind pushes it aside.

The abrupt slope, the inconvenient incline, the sudden bend in the river: these things are the jumping-off points from concept artist to real architect in a non-existent world. If you are going to make make-believe, then believing yourself, even briefly and even as a sort of game, has no serious side effects, just special ones.

A similar approach holds true for the other visual departments. Nothing goes out of style faster than bad design and effects. History, on the other hand, never looks fake. While this doesn't at all mean that historical reference should be a cut-and-paste image bank, it can be a never-ending source of inspiration.

THEN AND NOW

I'm sure it comes as no surprise if I say I never remember NOT drawing ... My first memory is of drawing something – or rather not being able to draw something.

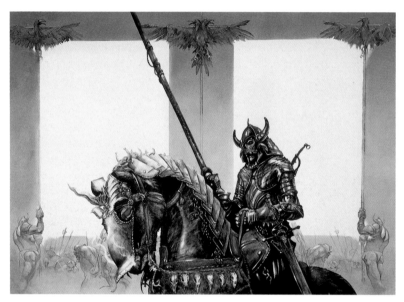

▲ **WITCH KING 1979**
This painting was done in my second year of art school. The king and his steed are cut out of one sheet of card and pasted on to another – obviously I had ruined the background. The frames were intended to hold text.
It is actually one of my first published Tolkien pieces, as it was reproduced in the 1987 Tolkien Calendar.

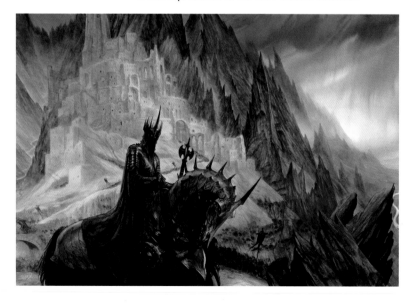

When I was four or so, my attempts to draw a cow were not satisfying (I grew up on a farm, they were familiar creatures) so I turned to my mother, who did her best to sketch one for me. Alas, her skills did not extend to draughtsmanship, and it wasn't much better than my scribble. 'That's not a cowwwww!' I very likely wailed as I burst into tears. I've since had few opportunities to draw cattle, but I did know that I wished to do something with pencils and paints. In school, I usually ended up in power mechanics or some other class I loathed – the art classes were full of kids who were too unacademic for any other discipline. I did get into art class for my last two years, and I owe a great deal to the art teacher, who put up with the rowdy crew I was happily part of and provided me with the first critical appreciation of my work outside friends and family.

At 19, I enrolled in an English-language school in France in order to spend a year abroad, and never really went back. The following year, I was happily sitting in first year illustration at the Ecole des Arts Décoratifs in Strasbourg, not understanding a thing. I kept practically nothing from my three years there, though one of the few pieces I did keep became my first published Tolkien-related artwork. But I did very much enjoy those years in school. Any school is a temporary assemblage of self-taught youngsters who happen to share equally temporary needs. I only truly appreciated what I had actually learnt a couple of decades later. It did me a world of good, despite launching me on a roundabout route through children's books and the French publishing industry, and imposed a certain clarity of thought on the ambiguous business of putting enough of oneself into what one does to be of interest, but not clouding the looking glass.

Most of my early jobs were just that, jobs in which I took pleasure (and for which I got paid), but in which I do not recognize myself. Many of my early books are now (thankfully) out of print. I've done

◄ **WITCH KING 2006**
The return of the Witch King, 27 years later, for a board game box cover. I do enjoy revisiting themes (if my well-furnished gallery of Gandalfs and Balrogs is any indication) and could happily paint versions of the same theme for months. So, what's changed? Certainly a firmer grasp of armour and a few technical tricks. Perhaps I should do another one in 2033, and see if there's any kind of pattern.

comics, advertising, cinema animation, maps, charts and graphics, historical drawings, half-sections of automobiles, kitchen plans, logos, alphabets, political cartoons, billboards, photography and many other jobs. I'm not particularly proud of any of them. Many times, I've accepted offers that were not meant for me, flattered by the request and hoping that I could find some advantage in doing them. For one of my first children's publications I re-did sketches three times, each batch a greater torture than the one before, and ended up doing colour illustrations I still cordially loathe. For one of my first paperback covers, I started seven times. I drew caricatures of nearly every 1980s politician, and slaved over acres of scratchboard to design lettering for ungrateful clients.

On the other hand, I've met dozens of extraordinary people through illustration. I've had the privilege to work on the other side of the world, and exhibit my work the world over. I've gained membership of an extraordinary confraternity of artists, many of whom I admired as demigods in my teens, many of whom have become friends. I've been privileged to make images for writers whose words have marked generations of readers. I've had the opportunity to make images the way I wished them to be, and the desire, or rather the need, to make them has opened my eyes to many things I would otherwise never have noticed. I have been privileged to work at home, to allow family life to intrude so fully in my work that there is no way I can separate the two.

It's hard work and filled with frustrations, dead ends and occasional sleepless nights, but I have never felt for one instant that I should do something else, and it is probably the feeling that I had something to say with images that led me to continue. That conviction, more than anything else, is an inner voice to which it is worthwhile listening. That voice has always urged me down whatever path my pencils lead me. I'm eager to get on with it. There is so much left to draw.

◀ ONCE UPON A TIME

One of a series of watercolours done in art school. The technique consisted of slopping watercolour on the board and turning it every which way until it dried in amusing patterns, then working up the details wherever the underlying splotches seemed to point.

And now …

While it's a cliché to ponder upon tomorrow at the end of a long book of thoughts, if you've gotten this far I'm sure I will be forgiven and you will read on.

Career plans and agendas are an illusory exercise, given the nature of the illustrator's profession. It is a full global undertaking, while remaining very personal. I seldom know what I will be working on in three months' time; to have a year's work planned in advance is a rarity.

Of one thing I have become aware recently, and that is the increasing weight of managing one's own little empire of copyrights and originals. It can be time-consuming, and the temptation is to spend more time doing that than actually working. Even more tempting is being invited to go and talk about what I do, so much so that it is easy to end up not actually doing anything any more, just talking about it. Happily, I decided long ago to keep my drawing to myself and not take on assistants or manage any brushes or pencils other than my own. I enjoy the contact I have with people whose lives are made up of words. Pursuing the visualization of a world that is growing in a writer's mind is exciting and rewarding. Writers are generally a strong-minded bunch, and if they don't like your interpretation they will say so.

Several years ago, I penned a chapter called 'Why I Don't Do Sketches' in the first book on my collected work (*Myth & Magic*, HarperCollins, 2001). Since then, I've filled up over a dozen sketchbooks – about 500 pencil drawings. While this reveals a truly remarkable inconsistency of view, I'd prefer to present it as a shift of certainties from the practical to the philosophical. I am far less determined now to apply particular methods and techniques and ever more unshakably convinced that means should not be confused with ends. I am impatient with the proliferation of registered trademark methods (put artist's name here, add ® and ©) and mortified by their popularity. It seems clear to me that the pursuit of the pictures in one's head can never be reduced to a recipe. To depersonalize something so intimate as drawing and painting is shocking. Guidance and advice, yes; mail-order methodology, no.

That's why this book is, or at least I hope it is, an artful fraud. In the guise of a how-to-draw book, it's actually something from which I hope to learn as much as you. Trying to put into words thoughts I have only ever put into images has convinced me of many things about which I had never reached any conclusions. Hopefully the answers it provides will not interfere with your work, and the questions it poses (which considerably outnumber the answers) will allow you to draw conclusions of your own and in turn ask the right questions about what you do.

How many words is a picture worth? A few anyway. Thanks for reading them.

AFTERWORD BY ALAN LEE

There is an eternal fascination with the idea of the artist revealing the secrets of the studio; as though by studying its layout, the arrangement of paints on palette, or the way that those pencils are sharpened we can grasp the methodology and absorb some of the inspiration.

I've looked at many of these 'How To' books over the years – usually while leaning against a shelf in a bookstore – mentally checking off their tips and wrinkles against my own, and filing away any new ones for future use. Sometimes the pleasure is akin to that of a well-produced recipe book – despite all those beautiful photographs of the ingredients and dishes, the luscious descriptions of tastes and smells, I know I'll never get around to cooking anything much more complicated than pasta; and I'll avidly read descriptions of the process of Fresco painting, memorising luscious words like 'arriccio' and 'intonaco', reckoning up the amount of fresh plaster I could cover in a day, even when I know that I'll be doing nothing but fiddly little watercolour illustrations for the next year or so.

Occasionally though, I'll stumble across something that offers more than daydreams and wishful thinking; John is a dreamer too, but he is also very practical, well-organised and – crucially – articulate, and is able to drip feed those vital insights into his artistic processes without either confusing or boring the pants off his readers. Brilliant! At last I'll have a book about an artist I admire which engages the mind, stimulates those parts of me that get excited by pictures of paintbrushes, and which, most importantly, inspires me to further experiments and efforts. And all that for the price of an afterword!

A few years ago John and I contributed to a book called *Fantasy Art of the New Millennium* (since 'Millennium' won't be a buzz word again for a while the publishers have changed the title to *Fantasy Art*). We were together at one end of the technological spectrum, with our burnt sticks and pigment, with those who work entirely on computers at the other. I think we were both quite happy to be part of the rearguard in this forward march; amazing work is being done by illustrators working in digital media at the moment, but there is always the slightly uncomfortable feeling that you are exploring a playground designed by people who are much smarter than you. This love of traditional methods is also tied in with a mutual fascination for earlier times and ancient stories.

What I really like about working in these older techniques – along with the satisfying smells and smudgy fingers – is the sense being in a dialogue with your materials. At times the dialogue is awkward – or even abusive – but there is always the sense of responding to, or being inspired by, how the paint is behaving on the paper. It is this quality of immediacy, fluidity and lightness of touch that appeals to me, and John's work is a perfect example of how a liveliness of mind, acuteness of vision and an urge to look at things from every possible angle can be reflected in the translucent, shimmering surface of a watercolour.

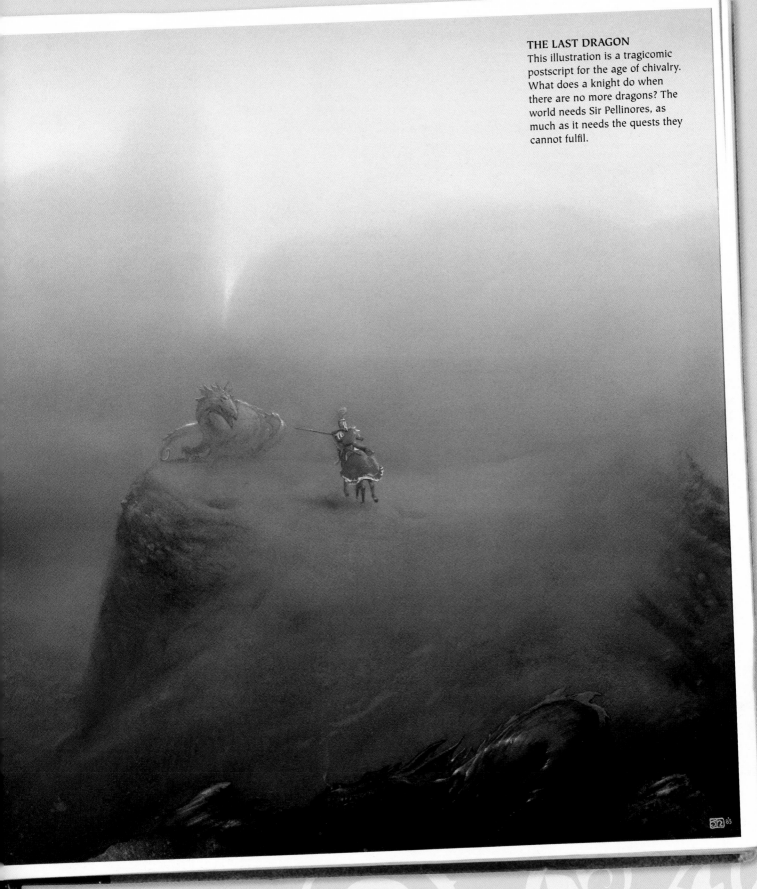

THE LAST DRAGON
This illustration is a tragicomic postscript for the age of chivalry. What does a knight do when there are no more dragons? The world needs Sir Pellinores, as much as it needs the quests they cannot fulfil.

ACKNOWLEDGMENTS

Thanks to all those who contributed to this book in ways big, small, straightforward or mysterious. Thanks to my mother, who couldn't quite draw that cow, thanks to all my art teachers for persisting in the belief art could be taught. Thanks to the team at David & Charles for affording me the opportunity to try words instead of pictures. Thanks to Terry for the words before and Alan for the words after. For the words between special thanks to Imola Unger, Beverley Jollands and Ian Kearey for helping me arrange the words in the cluttered attic that is my mind. And, thanks to my wife for her sharp eyes, perfect visual memory and impeccable taste; and to our son who chose another vocation but still thinks illustration is a respectable occupation and never forgets an image either.

ABOUT THE AUTHOR

John Howe was born in Vancouver in 1957 and grew up in British Columbia. He can't remember ever not drawing and John's talents and passion for the arts became evident at a young age; he then went on to study at the Ecole des Arts Décoratifs de Strasbourg. A gifted painter, illustrator and writer of children's books, John has been highly acclaimed for his work on J.R.R. Tolkien's books and associated merchandise over the last two decades. In recent years, John and fellow Tolkien illustrator Alan Lee have mesmerized audiences across the globe with their award-winning work as Conceptual Designers for Peter Jackson's *Lord of the Rings* film trilogy. John's work can frequently be seen in exhibitions throughout Europe, recently appearing at the prestigious Bibliothèque Nationale de Paris.

John's imaginative power is truly an inspiration. He is passionate about the need to construct fantasy on a foundation of authenticity, creating a world that is plausible and familiar in some way. His knowledge of the Medieval period is outstanding, and as a practitioner of living history, he extends his experience and knowledge of weapons, armour and fighting styles through re-enactments. This energy spills into his work – a distinct fusion of Medieval, Celtic, Gothic and Art Nouveau inspirations. And inextricably woven into John's fabric of detail, is his love of mythology and heroic tales. Combining serious craftsmanship and technical skill, vitality of communication and depth of dimensionality – John's art is as experimental as it is visual. John lives in Switzerland with wife Fataneh (also an illustrator) and son Dana.

To view John's portfolio visit www.john-howe.com

Following pages: *The Abandoned City*, from *La Ville
Abandonée*, John Howe © CASTERMAN S.A

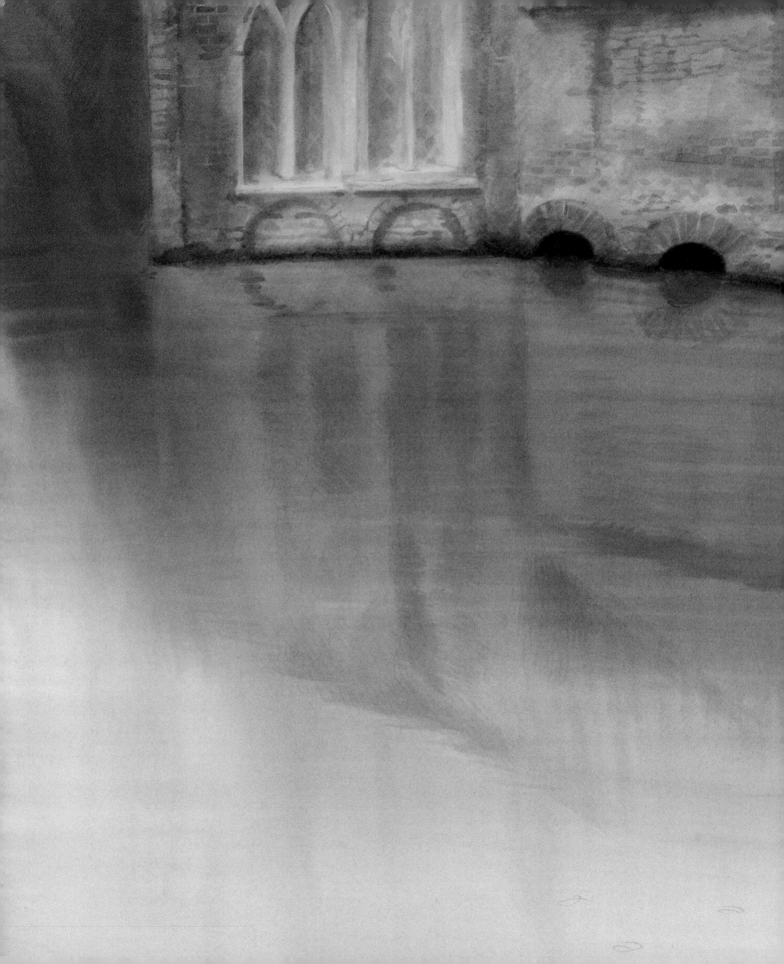

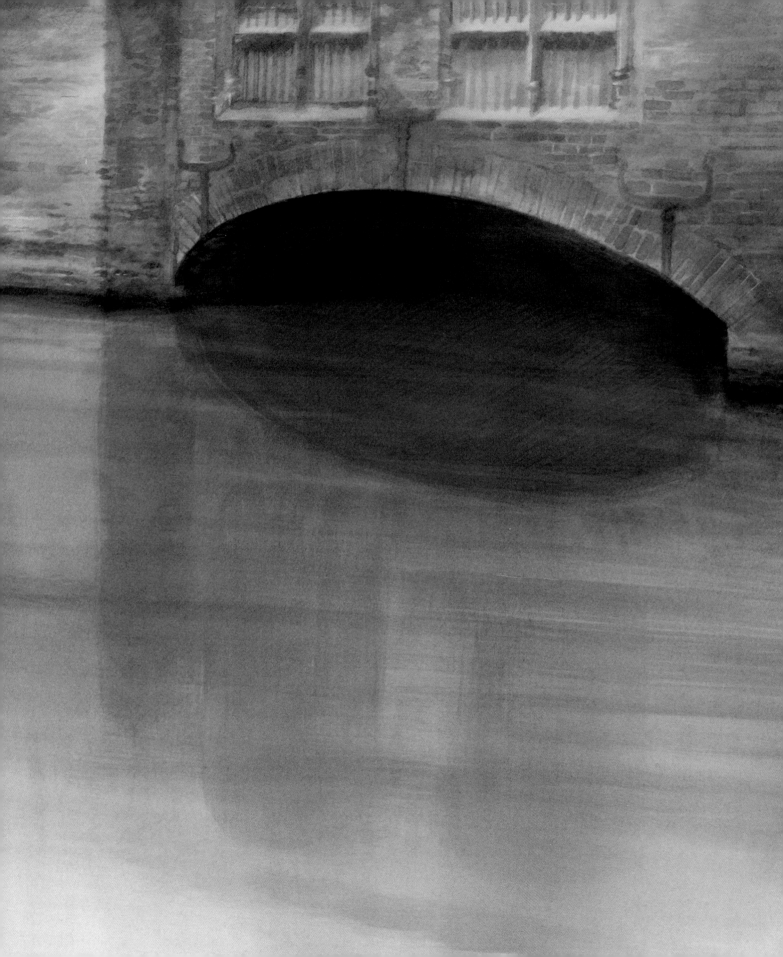